HORSES

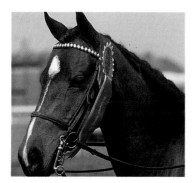

HORSES

Kit Houghton

·PARRAGON·

Acknowledgements

Bruce Coleman Ltd page 55; /**Melinda Berge** page 23; /**Thomas Buchholz** pages 36, 78; /**Kevin Burchett** page 61; /**Jane Burton** pages 70, 73; /**Erich Crichton** pages 66, 72; /**Christer Fredriksson** jacket; /**Michael Freeman** page 59; /**Michael Klinec** page 51; /**Colin Molyneux** page 64; /**John Murray** page 52; /**Fritz Prenzel** pages 9, 11, 12, 74–75; /**Hans Reinhard** pages 6, 38, 42, 46, 57, 58, 76; /**Kim Taylor** page 20; /**Paul van Gaalen** page 8; /**Jonathan Wright** page 63; **Kit Houghton** pages 13, 14, 16–17, 18, 19, 21, 22, 24, 27, 29, 30, 32-33, 34, 35, 39, 40, 43, 45, 48–49, 54, 67, 68–69, 77.

First published in Great Britain in 1994 by
Parragon Book Service Ltd
Units 13-17, Avonbridge Trading Estate
Atlantic Road, Avonmouth
Bristol BS11 9QD

Publishing Manager: Sally Harper
Editor: Anne Crane
Design: Robert Mathias/Helen Mathias

ISBN 1 85813 871 X

Printed in Italy

Contents

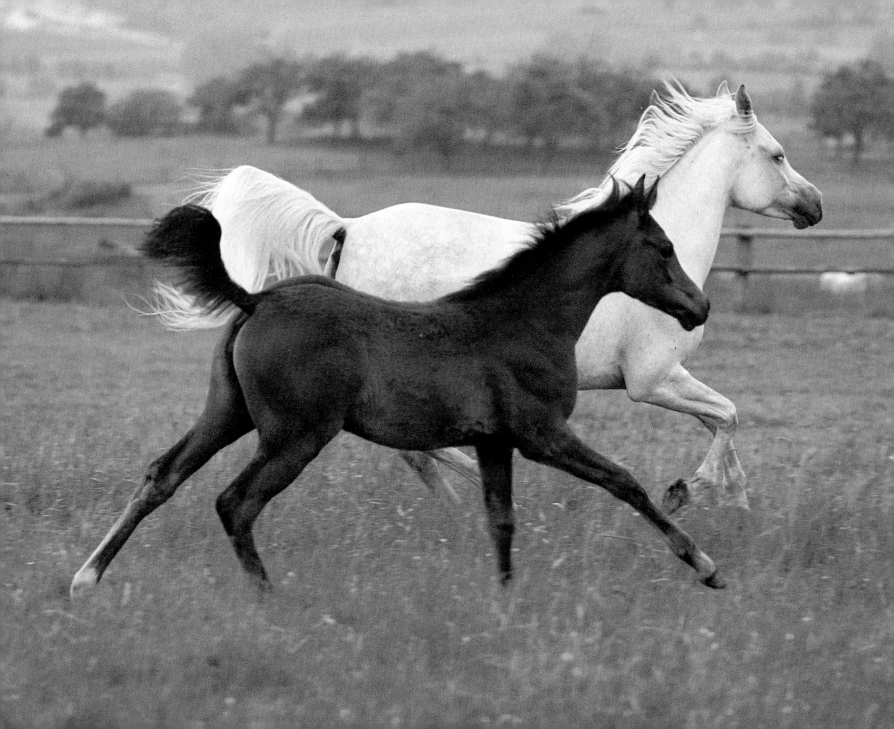

The Horse in History

The partnership between humans and horses is so close that it is difficult to imagine a world without the co-operation of the horse and its cousins, the donkey and mule. Even today, when the role of the working horse has mostly been replaced by the engine, there is still an enormously important role for the 150 million equidae (the collective name for horses, donkeys and mules) that exist throughout the world, particularly in the less-developed areas. Only six per cent of this global equine population are used for pleasure and sport. The remainder are working animals, with some one billion people relying on them for their livelihood.

Ancestors of the horse date back some 55 million years to fossils of *Eohippus* found in the United States. Also known as the 'dawn horse', this early progenitor of the magnificent hoofed creature of today was a rather unprepossessing little beast standing 25 to 50 cm (10 to 20 in) high. With four toes in front and three behind, these tiny horses proliferated and spread to Western Europe, crossing the land link that was to become the Bering Strait. Eventually *Eohippus* disappeared in the Americas when the great continental drift separated the Old World from the New, and horses were not seen there again until their re-introduction by the Spanish colonists.

Some seven million years ago *Equus caballus* began to evolve, which would have been much more recognizable to us today than its predecessors. These horses

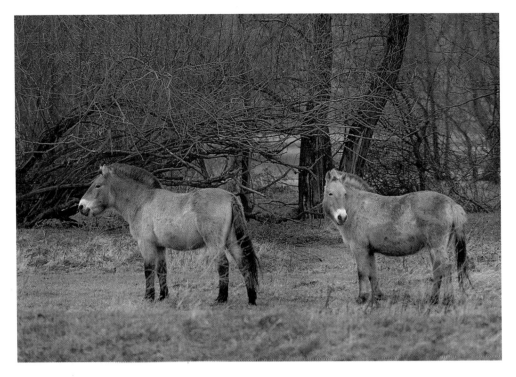

ABOVE: *Prewalski's horse is a different species to the domesticated horse.*

FACING PAGE: *The Arab is the oldest breed in the world, renowned for its toughness, stamina and beauty.*

horse, named after a Polish colonel who discovered a wild herd in Mongolia in 1881, has a chromosome count of sixty-six as opposed to sixty-four in the domestic horse.

The purest and most influential of all breeds is the Arab horse. There was a race of Arab-type horses in the Arabian peninsula at least 2,000 years before the Christian era. Their spread throughout the then known world was initiated by the Prophet Mohammed, and there is much evidence in the word-of-mouth stories and art forms handed down by the Bedouin people of the hardiness and speed of the Arab horse.

The Arab, acknowledged as the foundation stock of the thoroughbred, is the purest of all breeds. The thoroughbred horse was developed in England in the seventeenth and eighteenth centuries when native horses were crossed with oriental stallions. The foundation horses were the Bryerly Turk (1689), the Darley Arabian (1704) and the Godolphin Arabian (1728). These horses produced the three principal thoroughbred lines which are the background to all racehorses today. All thoroughbreds are recorded in the General Stud Book held by

moved around on hooves, and their two side toes were mere vestiges.

It is believed that domesticated horses were bred from *Equus caballus* that roamed the wild steppes of eastern Russia, while another closely related species, *Equus przewalski*, a native of Mongolia and the Gobi Desert, gave rise to wild horses such as the Tarpan. The evidence for this is the fact that Przewalski's

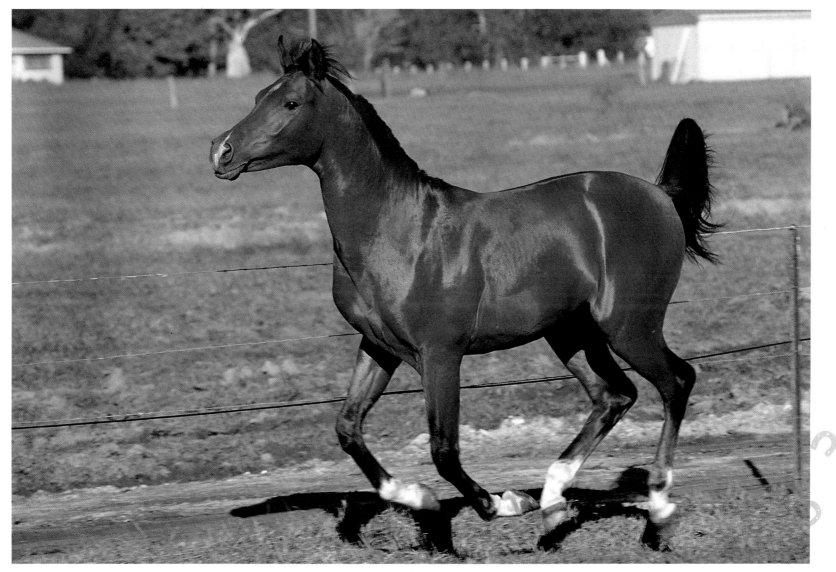

Wetherby's and each horse's lineage can be traced to the three original Arabians.

With selective breeding, the thoroughbred has developed far greater speed than its progenitor the Arab, but no horses can match the Arab for hardiness and stamina, making it the most popular choice for endurance riding.

With its unmistakable presence epitomized by its upstanding bearing, 'dished' face, generous eyes, upright ears and long flowing mane, the Arab appears to 'float' across the ground, holding its tail in a high and distinctive manner. Not surprisingly, this horse has provided inspiration for art and poetry for thousands of years. Today Arabs are bred extensively throughout the world, with the United States probably having the largest population. All countries breeding Arab horses have their own stud books, which are approved by the World Arab Horse Organization.

Horses are herbivores and in the wild graze on grasses and vegetation. When stabled and tended by humans they have a far more varied diet. For bulk feed they are given hay and dried grass, and this is supplemented by grains such as oats, maize and barley. Food additives include bran, molasses and beans of different types.

Foals are born after a gestation period of eleven months. Usually their birth is timed for the spring when the grass is at its most nutritive, which will benefit both the mare and her offspring.

As with many herbivorous creatures, the horse's only defence against attack is its speed in fleeing from a predator, so consequently foals are able to stand very shortly after birth. Within an hour they will be able to trot and even canter alongside their mothers. A playful foal, however, still relies heavily on the presence of its mother, and should not be out of her sight until it is ready to be weaned at six months old.

Evolution has demanded that a creature as sensitive as the horse should develop strong instincts in order to survive. For instance, it has a strong homing instinct and on many occasions a lost rider has dropped the reins and allowed the horse to find its own way back to the stable. Its acute sense of smell enables the horse to detect water at great distances, which can be an enormous asset to horse-owning desert tribes. The ability to sense the presence of hidden enemies translates

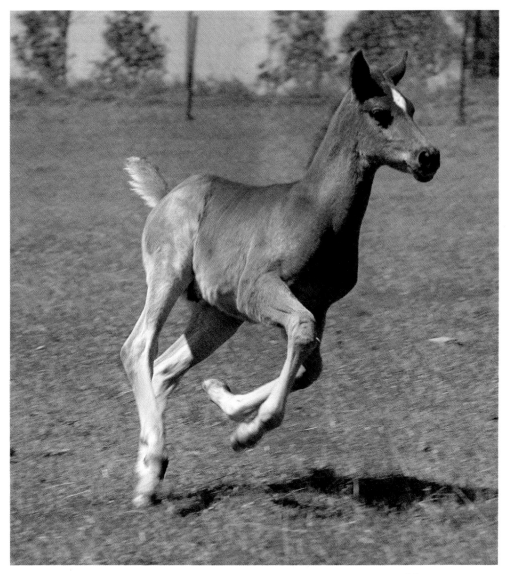

in modern horses as 'spooking', where there is no apparent danger but the animal will refuse to pass a paper bag which is rustling at the side of the road. Yet this same animal will fearlessly tackle the most daunting of fences in a steeplechase race.

Training the Horse

The first year in a domesticated horse's life is most important. It must learn how to be handled, haltered and led. The foal's legs picked up and its hooves will be examined in preparation for later attention by the farrier. If the horse is a Thoroughbred, it will officially become a yearling on 1 January (or 1 August if it is born in the southern hemisphere) in the year following its birth, even if it is only seven or eight months old. The young horse is called a colt or a filly depending on whether it is male or female. Castrated male horses are known as geldings.

LEFT: *From birth, the foal must learn that its owner, who is also the provider, must be obeyed.*

11

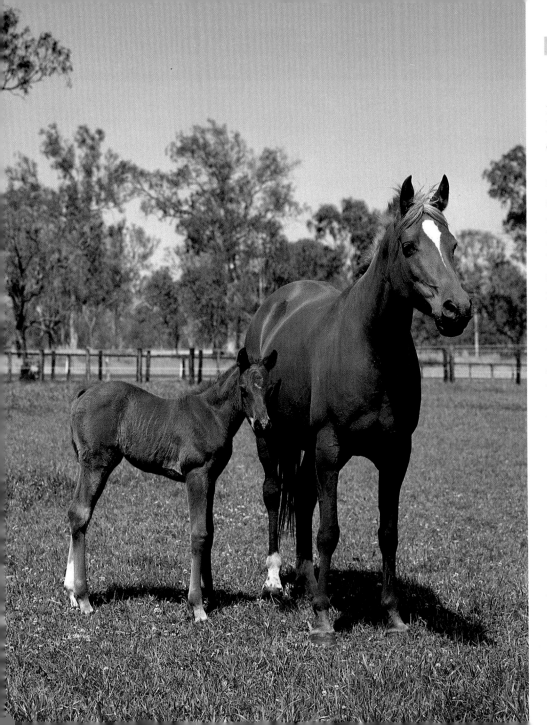

The Thoroughbred will be used for flat racing from the age of two. Most riding horses, however, will not begin their education until the end of the second year.

Methods of teaching a horse to accept the discipline of having a rider on its back or pulling a load, known as breaking, will vary depending on the use to which the horse will be put. Usually a riding horse will start off by being lunged (worked in a circle on a long line) or driven in long reins with the trainer walking behind. Lungeing and long reining helps develop balance and obedience, and at the same time the trainer will teach the horse voice commands. During this stage the trainer will introduce the 'bit' into the horse's mouth. The bit is usually made of metal and jointed in the middle to encourage the horse to play with it – a practice described as 'mouthing'. When the horse has become accustomed to the saddle and the feel of the girth holding the saddle in place, the rider will then lie quietly across the saddle while an assistant leads the horse around.

When the horse is no longer worried by this, the rider will climb gently into the saddle. Normally this will happen at the end of the horse's third year and will

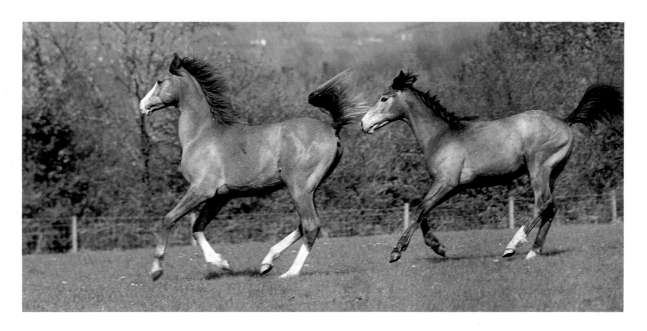

ABOVE: *Two Arab yearlings test out their paces.*

FACING PAGE: *Horses continue to develop and grow until they are six or seven years old.*

form the ground work for more serious work the following year.

Once the basics are understood and the horse's balance is established, the young horse is ready to go on to more specialized training. Each sport has its own requirements, perhaps the most basic being flat racing where the horse is taught to run in a straight line and to run 'upsides' (gallop alongside other horses). At the other end of the spectrum, the Grand Prix dressage horse is trained for many years to respond to the lightest of commands from its rider, and may not be ready for top-class competition until it is eight or nine years old.

The earliest known written work on training horses was by the Greek Xenophon and appeared over 2,000 years ago. His natural methods are still applicable today, but his knowledge was lost for many hundreds of years. By contrast, the knights of the Middle Ages relied on vicious curb bits and sharp spurs to force their horses to respond to their commands.

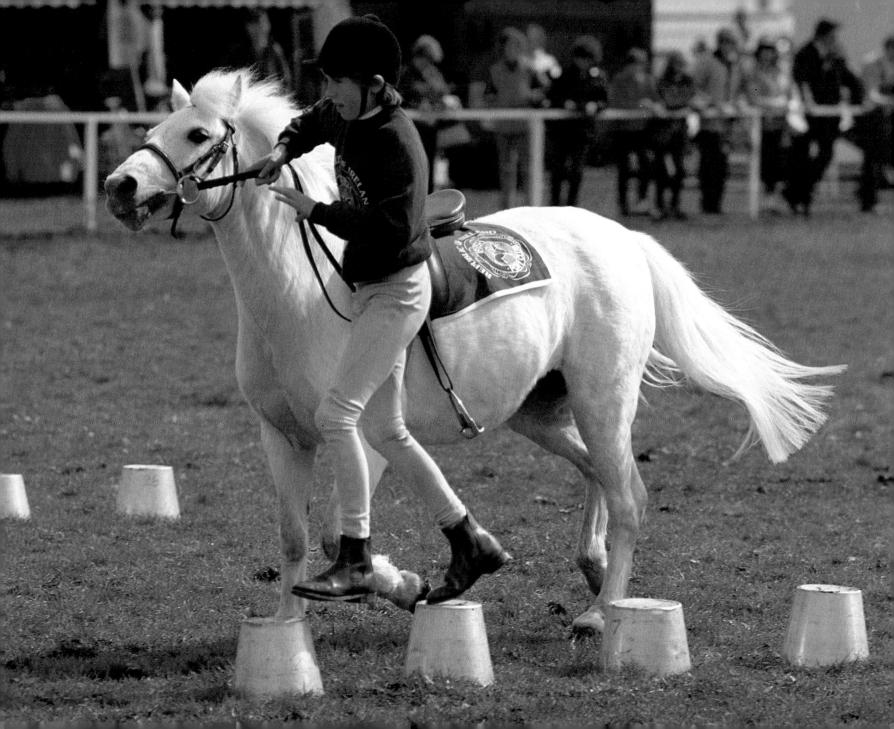

Ponies for Pleasure

FACING PAGE: *A Southern Ireland team member taking part in Pony Club Games.*

Apart from the obvious difference in height, ponies have deeper bodies and stronger legs in relation to their size than horses. Native ponies are particularly sturdy and strong and are able to carry considerable weights; most people will have seen photographs of, for example, small Shetland ponies carrying adults. Their manes and tails are thicker to protect them against cold and wet, and they are generally more sure-footed, quicker-witted and have a stronger sense of self-preservation than horses do.

Ponies normally measure between 10 and 15 hands high. The hand measurement (hh) is medieval in origin and is the approximate breadth of a man's hand, accepted as 10 cm (4 in). Measuring in hands is mainly a British and American convention. Elsewhere the measurement is more commonly made in centimetres. A horse or pony is measured from the withers, at the base of the neck, down to the ground.

Many children, in particular girls, go through a stage of being obsessed by horses, but few of these are actually lucky enough to own their own pony. The fortunate few, provided they are dedicated, will have the most marvellous fun with their ponies, but it is essential, as is true for any pet, that the animals are well cared for. Those who are fortunate enough to have knowledgeable parents will have on-the-spot guidance, but others have to learn from books, lessons or video tapes.

In Britain, the Pony Club – part of the

British Horse Society – has branches throughout the country, and there are also clubs in many other parts of the world. They give lessons at their regular rallies, and their network provides an excellent way of acquiring a pony, whether you wish to buy or borrow. You may also stand a chance of finding a quieter, well-trained pony, whom its owner has simply outgrown. There is nothing quite as disappointing as acquiring an unsuitable pony – a mistake that even the most knowledgeable person may make. Purchasing a novice pony for a novice rider is most certainly not to be recommended.

When buying a pony, do take an expert on horses with you, whose opinion you are prepared to accept. So often, as with any purchase, the heart is guided by the eye, and it is easy to find yourself with a pony that is headstrong, ill-mannered or just plain dangerous but still looks beautiful.

For the first-time owner, it is always best to buy a second-hand pony, with a full service history (as they would say in the motor trade). Riding schools and equestrian centres can sometimes be persuaded to part with a valued pony with which a child has already established a partnership through regular lessons. Most keen children, who do not have their own ponies, will already have spent all their weekends and holidays at their local riding school, helping with the most basic jobs such as mucking out stables, cleaning tack and grooming muddy ponies. This is an excellent environment in which to learn about horses, as the child will gradually gain practical experience in a knowledgeable atmosphere. Of course, not all riding schools are of a high standard, but in most countries each riding school is inspected by local government authorities and only those reaching the required standard of safety and care are issued with a licence.

No rider knows everything about horses and riding, so you will never reach a stage when a riding lesson isn't worthwhile. Even top competition riders still have regular lessons. Of course, there are many who do not wish to ride in competitions, but are content to hack out in the countryside or along bridleways, but even

RIGHT: *A suitable beginner's pony may be one that has been fully trained but outgrown by its previous owner.*

16

for them, basic comfort and fun are enhanced if the rider knows how to sit correctly and control the horse or pony. Riding lessons can take many forms, but the most usual is teach riders in groups in a school or *manège*. Even the most badly behaved pony cannot escape to freedom in such controlled conditions, and the majority of animals seem more accommodating while their riders are trying to master a technique.

Lessons in indoor schools are marvellous if the weather is bad, but can at times be dusty, depending on the riding surface. It is equally possible to ride out with a competent equestrian and be given tips on the ride, including body position, tension on the reins, and aids to the pony. An 'aid' is the method of communicating with the pony, giving it commands using a combination of signals sent through the rider's legs, seat, hands and body.

Much can be gained by getting to know the character of your pony as, just like humans, each has its own likes and dislikes. Often, even a small sign such as the backward flick of an ear as you are putting on the saddle may be a signal that the animal is worried, and the sound of a reassuring voice may be all that is needed

ABOVE: *A prize-winning pony, well-groomed and in the peak of health, is a glorious sight.*

to calm any fears. In the case of a young pony, you can usually overcome any uncertainty by quiet repetition of the movement, but sometimes with an older pony, especially one that has at some time had an unfortunate experience, you need to adopt a different approach. Soothing but firm handling is often the most helpful, talking to your pony all the while. Most horses and ponies are used to the voice being used with a command, as it is normal practice to use the voice as an aid when breaking in.

Horses and ponies change their coats according to the season, and in winter grow a thick dense coat which they will cast off in the spring, so that rather like the ugly duckling becoming the swan, they appear sleek and beautiful once again. Wild ponies, with their dense coats and protective grease to keep out the elements don't need grooming, but domesticated ponies require brushing before they are ridden, firstly to remove any mud, particularly where the saddle is to go, and secondly to check for any sore or chafed spots that may have developed underneath the mud during the bad weather. If any mud or dried sweat is left on the saddle patch, the pony may well become

sore if it is then saddled and the girth is done up too tightly. It is equally important to dry off any sweat marks after riding, as ponies can easily catch a chill if they are turned out with wet sweaty coats on a cold day.

A visit from the farrier is an expensive necessity. Tarmac roads wear down hooves, so you must expect to shoe your pony at approximately eight-week intervals, depending on use and how the pony wears its shoes. Resting ponies require regular hoof trimming as their feet grow all the year round, and neglect can result in the most appalling conditions. If you intend to compete regularly at horse shows, it may be wise to vaccinate your pony against equine flu. The vaccine can also include protection against tetanus, which will help in the event of an accident.

A common problem for pony-owning children is care of the pony during school term time (particularly if a child attends a boarding school). Many parents find that they are left to cope with muddy outwintered mounts, and it is vital that proper provision is made for their care. Ideally, the child should look after his or her own pony; there is no better way for them to

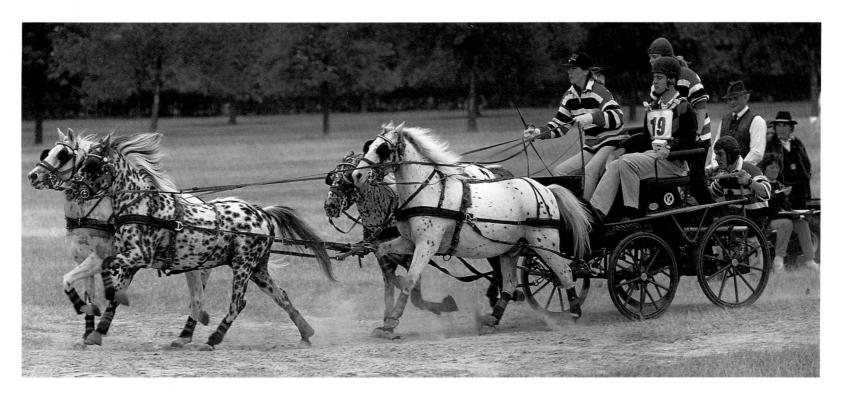

ABOVE: *A team of leopard- and splash-spotted ponies taking part in a carriage driving competition.*

learn the ropes. But do not underestimate the amount of dedication that is required. If your pony is turned out to grass you must, even in the sunniest weather, check it at least once and preferably twice every day; always check the water supply; and look your pony over – it may have injured itself overnight and immediate care can often prevent a small cut becoming infected.

The majority of the native 'woolly' ponies are often far better wintered out in a field as they are not bred for a cosseted stable life, but this can lead to another set of problems, such as grooming a wet and muddy pony before riding. If you intend to ride your pony regularly, a New Zealand rug made of weatherproof material will help keep it warm, dry and a little cleaner, but the rug will have to be checked twice each day to ensure that none of the straps have become undone or that the pony is chafed on the shoulders by an ill-fitting rug. Ideally the pony

ABOVE: *Ponies need to be exercised or turned out in a field every day.*

should have access to a field shelter, where it can eat its hay and food away from the rain. Most native ponies, if they are not being ridden, are quite happy with a diet of grass and additional hay, with perhaps a little hard food if the weather becomes inclement. A more highly bred pony with thinner skin will benefit from being stabled at night, but will then require twice-daily attention, involving mucking out and feeding with a suitable diet. If you do not have your own land and stable, a livery stable, where the pony may lodge, could be an answer.

The livery arrangements can vary, from full care of the pony (including feeding, mucking out, grooming and exercise) to the more economical DIY livery, where a stable and use of the paddock are paid for, while the work is done by the pony's owner. This often works out well, as the livery centre will normally allow access to

schooling and jumping areas, and, if you are very lucky, use of an indoor school.

Competing With Your Pony

There are many differing levels of competition, varying from the international championships to the small local show and gymkhana. The local gymkhana, which is all about fun and games on ponies, often includes items such as potato races and bending races. To compete in a potato race, you and your mount have to collect and deposit potatoes at speed from and into buckets. The more expert participants have been known to complete the task while some are still struggling with their second potato.

Bending races involve weaving in and out of bamboo poles, with some of the ponies becoming such dab hands at the job they almost run the race unaided.

RIGHT: *Most riders are happy to compete just for fun; to earn a rosette at the end of the day is a bonus.*

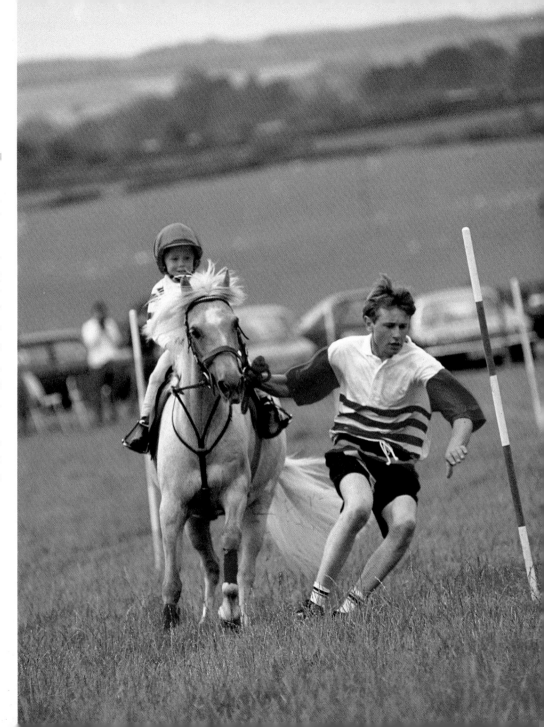

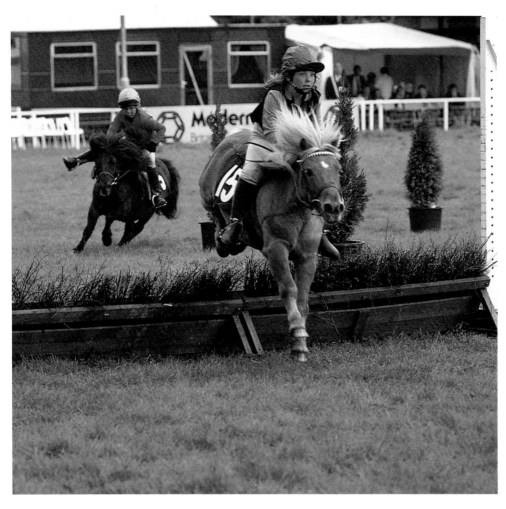

The glamorous showing classes tend to be at the beginning of the day, followed by the show jumping, so that the smart attire of the pony and rider is not spoiled by the more athletic gymkhana races. In most countries, no rider can now compete without a hard riding hat (normally now a crash helmet covered with a coloured silk) and riding boots.

Some Pony Club rallies are held regularly in school holidays, where instructional grouping ranges from the beginner to the expert, giving everyone a chance to improve. General schooling of pony and rider is the basis for the instruction, but most Pony Clubs are also able to select teams to compete in area competitions for dressage, show jumping, eventing and mounted games, tetrathlon, polo and also more recently, polocrosse, a cross between lacrosse and polo.

Throughout the Pony Club year, preparations are made for the major competitions, with special practice sessions for the short-listed riders and their mounts. Many could not compete, however, without the help of self-sacrificing parents, who often have to become chauffeurs and grooms. Most, though, wouldn't miss it for the world!

ABOVE: *The Shetland Grand National has raised valuable funds for charity through the years.*

FACING PAGE: *Polocrosse is a relatively new sport, a cross between lacrosse and polo.*

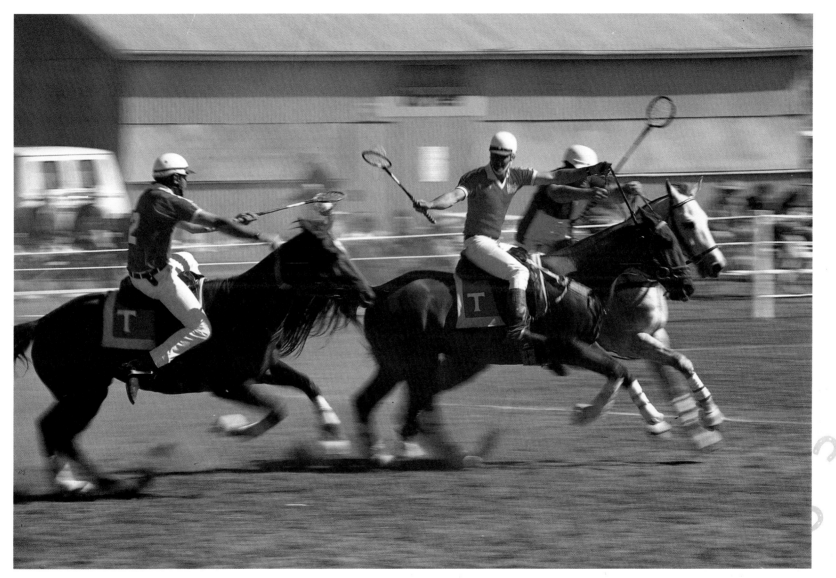

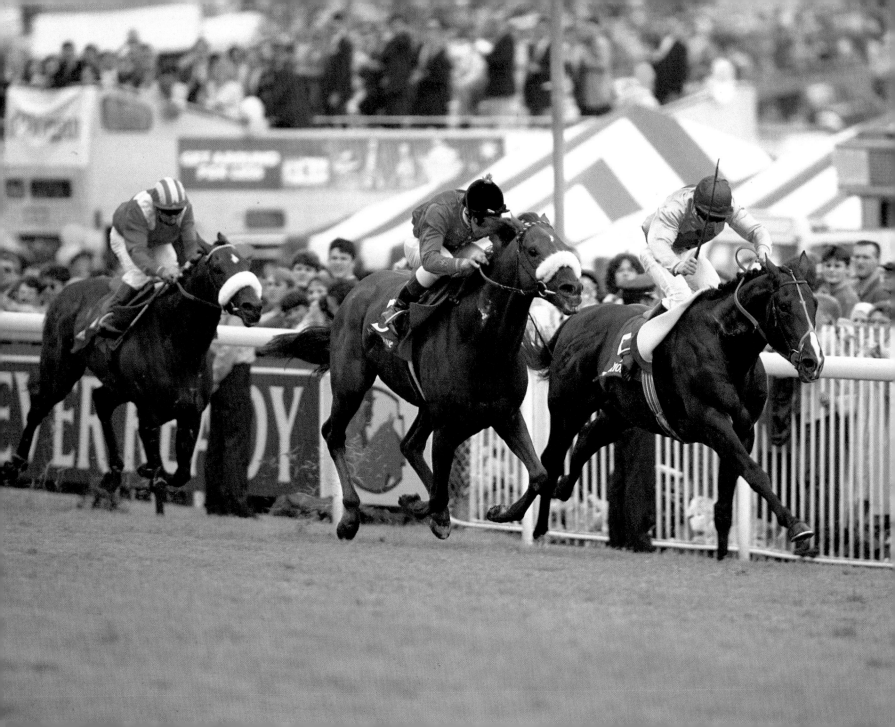

Racing Horses

Nothing can compare to the heart-stopping moment when a thousand pounds of super-fit horse flesh flash past the winning post in a tremendous thundering of hooves. A diminutive jockey, sporting the owner's colours, crouches over the horse's withers.

This scene now happens on race courses around the world, with spectacular backdrops provided by rolling hills, green turf, desert dunes, snow-capped mountains or, in the case of Chantilly, near Paris, France, a magnificent palace for horses. Built in 1836 by the Duc d'Aumale, these luxurious stables were to fulfil the prince's belief in reincarnation. His firm belief was that he would return to earth in the form of a horse, and wished to ensure his future comforts.

FACING PAGE: *Racing is known as the 'Sport of Kings', and for centuries has enjoyed royal patronage.*

Racing is described as the 'Sport of Kings', and is also the stuff of dreams: the dream of breeding or buying a horse that will outrun all others to capture one of the classics in the racing calendar. This dream goes back many centuries and it was through royal patronage that racing in England saw its birth when James I 'discovered' Newmarket in 1605. He used the area as hunting grounds and built the first race course there.

It was the English king, Charles II, during the Restoration (1660-88), who was considered to be the father of modern racing. A great enthusiast, he was the only royal to race-ride until Prince Charles and the Princess Royal (Princess Anne) both competed in amateur races during the 1980s.

The Thoroughbred horse was developed at the end of the seventeenth and beginning of the eighteenth century. It was derived from three foundation sires, which were imported from the East and crossed with native mares. Through years of selective breeding, the thoroughbred has become the fastest of all breeds. Its lineage and pure blood is fiercely protected through the General Stud Book which was compiled by James Wetherby in 1793 and listed the pedigrees of every thoroughbred in England. Because of this meticulous record keeping, it is still possible today to trace the lineage of every racehorse directly to the three founding sires.

There is sometimes confusion over the word 'thoroughbred'. It does not simply designate a purebred animal, but also refers to the particular breed which has been systematically selected over the years for speed and stamina. Its conformation and temperament are specifically suited to racing.

All Thoroughbreds share the same birthday of 1 January in the northern hemisphere; in the southern hemisphere, where seasons are reversed, they have their birthday on 1 August. Thorough-breds vary in size and colour, and although never piebald, they are sometimes spotted like the Tetrach, which was born in 1911. 'The Spotted Wonder', as he was known, was a fabulously fast racer and passed on his genes for speed to many of his offspring.

Thoroughbreds can start racing as early as two years old and their introduction to racing will normally be short-distance sprints. The minimum length for these races is 1 km or 5 furlongs (a furlong is one-eighth of a mile and was traditionally the length of a furrow in a field). As the season progresses so do the distances these young horses will run.

In England until a few years ago, all races were run on turf grass courses, which can be quite undulating; perhaps the most famous is the Derby course at Ascot, with its long uphill gradient to the finish. In the United States, flat-racing courses are literally flat and oval-shaped and run anti-clockwise. Australia's races are held on an oval track. The surface, known as 'dirt', is an all-weather surface consisting of a mixture of sands.

At three years of age, racehorses are challenged with increasingly demanding tests of speed and stamina and it is in

RIGHT: *The Epsom Derby is one of the most prominent events on the international racing calendar.*

their third year that they are entered for the classic races. These are the most prestigious on the racing calendar. There are five English classic races. The St Ledger is the oldest of all, and has been run at Doncaster since 1776 over a course of 2.8 km (1¾ miles). At Newmarket there is the Two Thousand Guineas and the One Thousand Guineas, both of which are run over 1.6 km (1 mile). The latter race is reserved for fillies. The Oaks is a 2.4 km (1½ mile) race for fillies and was first run at Epsom in 1779; but perhaps the most famous of all is the Epsom Derby, a race of 2.4 km (1½ miles). The name of the race was decided on the toss of a coin when in 1780 Lord Derby and his friend, Jockey Club director, Sir Charles Bunbury, founded the race. The toss was won by Lord Derby, but Bunbury's horse Diomed won the inaugural race.

The ultimate accolade in flat racing is the Triple Crown: the Two Thousand Guineas, the Derby and the St Ledger.

27

There have been very few horses to achieve this honour. The latest was Nijinsky in 1970 and as racehorses now tend to specialize in certain distances, there is less likelihood of one horse winning over such a variety of distances.

Ireland has been as responsible as any country for the worldwide popularity in racing. The Emerald Isle is renowned for the perfect conditions it provides for raising horses, with its mineral-rich soil and lush grass, so vital for building the strength needed by the young racehorse. The racing aristocrats of England founded many stud farms in Ireland during the eighteenth century and by the nineteenth century Ireland had become the main force in thoroughbred breeding. The disastrous potato famine of 1840, however, forced many to flee Ireland and start new lives in America and Australia, taking with them their unique skills in raising and caring for horses. In this way they helped form the foundation of racing in these countries.

The Training Programme

Training a racehorse is a mixture of science and art and depends on the talents of a team of specialists, headed by the trainer. These specialists include jockeys, veterinarians, grooms, blacksmiths and racing secretaries. The size of a training establishment may vary from an individual operation with two or three horses up to the major establishments around Newmarket with upwards of 200 horses and numerous employees. Early in the morning around the heath at Newmarket or on the training gallops in the forests around Chantilly, strings of racehorses can be seen walking or cantering past the trainer mounted on a quiet hack. The trainer will be watching each horse to gauge its level of fitness.

The training programme varies with each horse, but the usual way is to start with daily walking and trotting to help develop muscle and strengthen legs. The walking may go on for at least six weeks, particularly with young horses who take longer to shape up than an older horse. Where possible, the horses undergo uphill work, which helps to increase stamina, then they progress to slow cantering and the occasional gallop. Each lad or groom has several horses assigned to them, and it is up to them to learn the habits and foibles of each horse. The

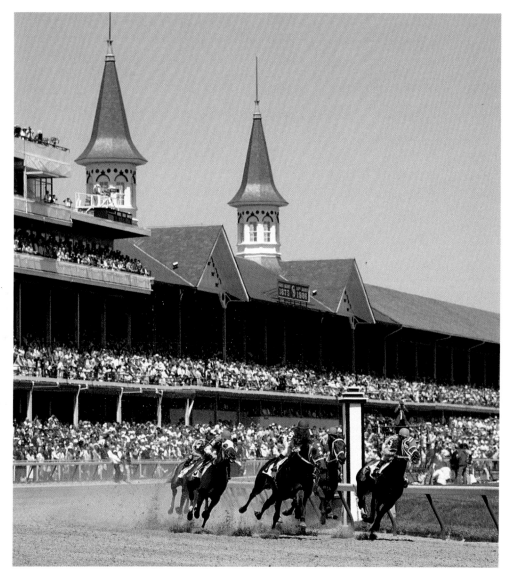

stable jockey who is retained by the trainer tries each of the horses to assess their fitness and ability to race. This is particularly important with young horses to determine how willing they are to race against their contemporaries.

Racehorses lead pampered lives and with more technology entering the racing world, their health and general well-being are very closely monitored. Equine swimming pools are common at many racing yards. Here in a circular pool, horses with minor injuries or strains can exercise by swimming without putting any strain on their legs.

Treadmills are becoming increasingly popular. They are a moving walkway and by varying the speed, a horse can walk, trot or even canter. The angle of the treadmill can be altered in order to simulate uphill work. The treadmill reduces the concussion felt by the horse as it exercises on a hard surface and makes it easier to monitor the length and intensity of exercise. Many horses are now weighed on a weekly basis to check their

LEFT: *The Kentucky Derby is held on an all-weather surface made up of a mixture of sands.*

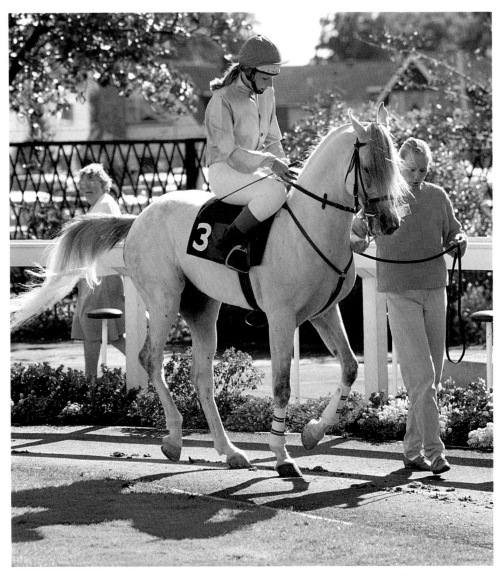

condition and many trainers have access to sophisticated laboratories for sampling horses' blood to check their health.

Despite all the technology now available the speed of a racehorse has not increased noticeably. For example, the fastest time recorded for the Epsom Derby – 2 minutes 33.8 seconds – was first achieved by Mahmoud in 1936. At the end of the day, the most important factors in producing a fine racehorse are stockmanship, and an awareness and sensitivity to the animal's needs.

At the Race Course

On racing days, horses are given a light feed and then prepared for travelling. This involves bandaging or wrapping protective covers around the horse's legs, and putting on a tailguard and a poll-guard to protect the horse's head when travelling in the lorry on its way to the race course. A travelling lad accompanies the horses in the vehicle and is responsi-

LEFT: *Before a race, the jockey takes time to assess the horse's condition and mood.*

ble for keeping an eye on them throughout the day. Once at the course the horse is walked around to get rid of any stiffness in its legs from the travelling and then rests in one of the race-course stables until half an hour or so before the race. The trainer then saddles the horse and leads it around the parade ring. It is here that the public has a chance to see the horse and compare it with others entering the race. The horse's owners stand with the trainer in the centre of the parade ring and meet the jockey. The horse will either be ridden by the stable jockey, an apprentice jockey or a freelance jockey who may have never seen the horse before.

A bell rings to signal the jockeys to mount up. The trainer checks the horse's girths to ensure that they are tight and the saddle cannot slip. For everyday riding only one girth is normally used, but in racing an extra girth (a surcingle) which goes over the top of the saddle gives added security. The jockey is given a leg-up by the trainer into the saddle (or plate as it is called in racing), which, aptly enough, is not much bigger or heavier than a soup plate, as weight plays such a crucial part in racing.

The horses then parade around the ring a few more times, before being led out on to the course by the groom. The horses normally canter past the grandstands on their way to the starting post, giving spectators another chance to have a good look at their fancied mount and the jockeys a chance to settle the horses and assess how they are feeling. As with any athlete, horses can have 'off days' when they are not feeling quite up to scratch and the jockey needs to be aware of this. In many cases the jockey will never have sat on the horse before so they will have only a very short time to get used to the way the horse goes and to mull over the instructions that will have been given to them by the trainer.

In the United States racehorses are 'ponied' down to the start of each race. In other words, they are led by one of the race-course staff, who rides a reliable and level-headed pony. This helps to give the skittish racehorses confidence and keep them quiet and out of mischief on their way to 'post', a racing term for the start. Once at the start the horses circle around and the girths are checked for the last time before each horse is led into the starting stalls. Starting stalls are mobile

steel structures which can be set up at different points along the race course depending on the distance of the race. Each racehorse is loaded into its stall by an expert team whose job is to ensure that the horses go into the stall quietly and without fuss. The procedure will have been practised on most days at the trainer's yard, but some horses in the excitement of the moment still refuse to enter the stall. In this case a hood is pulled over the horse's head which very quickly calms it, and once in the stall the hood is pulled off by the jockey. As soon as all the horses are loaded in the stalls the starter shouts a warning to the jockeys to be ready. The starter then drops a lever and the gates of the stalls spring open simultaneously releasing the horses in an explosion of action on to the course. It is here that the balance and strength of the jockeys are put to the test to ensure that the horses are under control and in a good position for the race.

Jockeys ride with very short stirrups, placing their centre of balance over the horse's shoulders when galloping. This makes the jockeys more compact as they sit hunched over the horse's neck. They also sit as still as possible in order not to unbalance the horse and to give it the freedom to maximize its abilities. When the jockey wants the horse to go faster, they mostly use their 'hands and heels'; that is, they push at the horse's neck with their hands and kick with their heels. They use the whip with discretion.

Riding a finish is almost an art form and the mark of a truly great jockey is knowing exactly when to ask more of the horse to get it to use that extreme last effort to put it in front of its rivals.

In England the main flat-racing season runs from March to November, but with all-weather tracks it is now possible to enjoy flat racing all year; however, many jockeys move on to the Far East or Hong Kong to race throughout the winter making it a year-round occupation.

Jockeys have to be small and finely built. The ideal weight for a jockey to remain within the standard weight allowances is 50 kg (110 lb), and it is for this reason that so many jockeys have to keep up a relentless regime of dieting,

RIGHT: *When jockeys weigh out before each race, they carry their saddles, which count as part of their overall weight.*

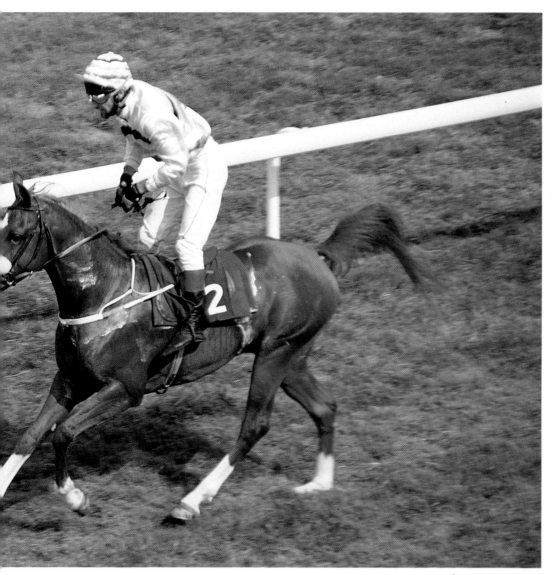

sauna sessions and general fitness.

One of the most famous flat-race jockeys of all time is Lester Piggott, who at 1.73 m (5 ft 8 in) is tall for a jockey and therefore has a constant battle to keep his weight down. Unlike many top athletes, jockeys can remain at the top of their profession for many years. Piggott had his first Derby win in 1954 on Never Say Die at the age of eighteen. He retired in 1985 at the age of forty-nine, only to make a comeback a few years later.

The rewards for jockeys can be enormous, with many of the top earners becoming multi-millionaires. It is, however, a gruelling route to the top: staying fit enough to be able to withstand a pull that has been measured at 68 kg (150 lb) on each arm while keeping one's weight to a minimum, plus driving many thousands of miles every year between race courses, does have its disadvantages.

Steeplechasing

It is towards autumn that the steeplechase season begins. For many this is the most exciting form of racing. A steeplechase horse, while still a Thoroughbred, tends to be a more sturdily built animal

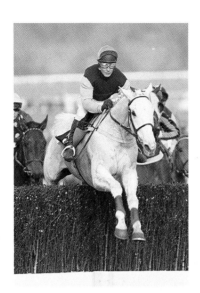

ABOVE: *Desert Orchid, an outstanding racehorse with an indomitable will to win.*

FACING PAGE: *The steeplechase course includes one ditch fence and one open water jump.*

than its flat-racing cousin, and does not start its racing career until the age of four, usually in a hurdle race. The obstacles are rather like sheep hurdles – thin rails packed with gorse and set at an angle leaning away from the direction that the horse has to jump. This makes them easy to brush through should the horse make a mistake.

Steeplechase fences are much more substantial and upright. The rules require at least twelve fences during the first 3.2 km (2 miles) and six fences in each succeeding mile. The fences are designed to imitate natural hedgerows. The race distances range from 3.2 to 6.4 km (2 to 4 miles).

The training of steeplechase horses mirrors very closely that of flat racers, except for the jumping tuition. It is most important that a horse learns to place itself correctly for a fence and to 'see a stride'; that is, to know at what point to take off to clear the fence safely.

The highlights of the steeplechase season in Britain are the Cheltenham Festival and the Grand National. Cheltenham is a three-day meeting held in early March and its most famous race is the Cheltenham Gold Cup. Run over 6

km (3 3⁄4 miles), this race has been won by some of the most famous horses in racing, including Arkle, who won for Ireland three times in 1964, 1965 and 1966. More recently the great grey hero, Desert Orchid, won in 1989.

Described as the greatest horse race in the world, the Grand National has had its share of heroes, in particular Red Rum, whose Grand National record is unique. He first won in 1973, again in 1974, then came second in 1975 and 1976. At the age of eleven, he won for the third time in 1977. Red Rum's career started quite modestly, with only eight wins out of forty-nine starts, when he went to trainer 'Ginger' McCain. Diagnosed as having chronic lameness, Red Rum was nursed back to health. When his racing career was relaunched, it was his uncanny jumping ability which gave him his place in the history books.

Several countries have their own particular fence types. For instance, in Ireland horses sometimes jump natural banks, and in the United States there are timber fences which are solid, upright and some 1.3 m (4 ft 3 in) high. Once considered the poor relation to flat racing, steeplechasing has become a major horse sport

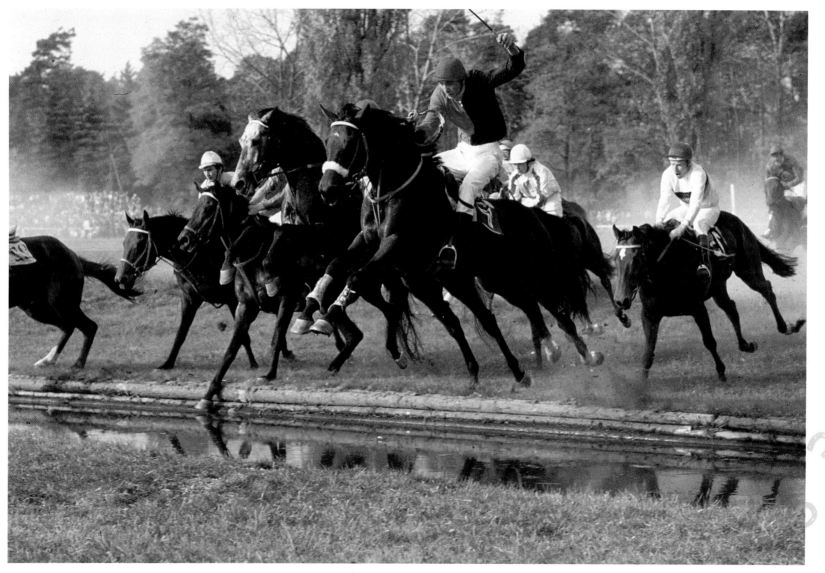

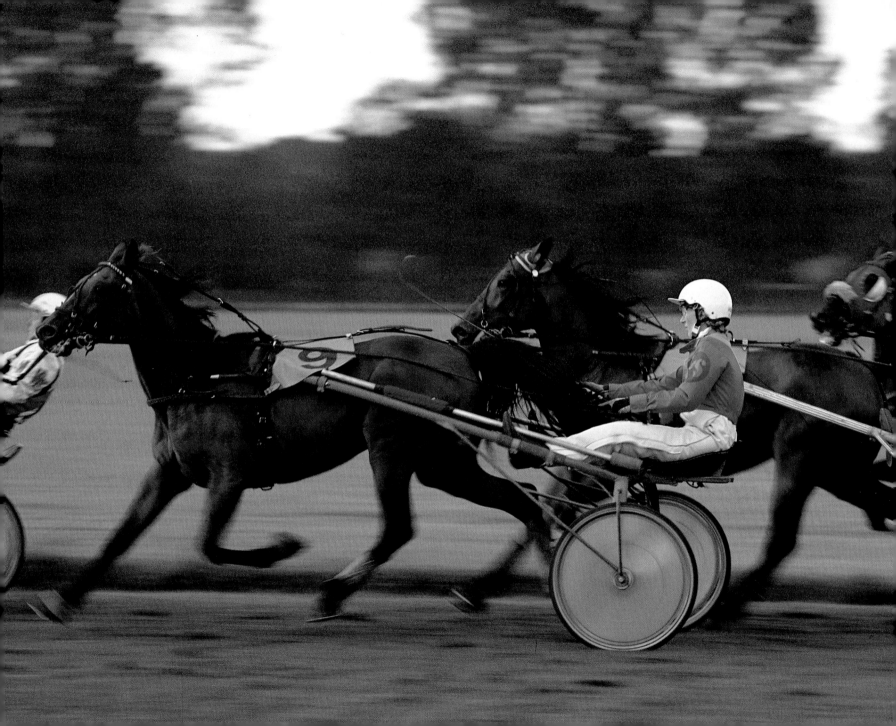

with perhaps more sporting enthusiasm and scope for the amateur than the hard-nosed business of flat racing.

Trotting Races

Harness racing or 'trotting' is, in France, Australia and the United States, second only in popularity to flat racing. It is derived from the ancient sport of chariot racing. Today the driver sits in a light-weight two-wheeled vehicle known as a sulky, and the horses race around an oval track at a trot or a pace. They must not break into a gallop. The trot is a two-beat gait in which each diagonal pair of legs move alternately; in the pace, also a two-beat gait, each lateral pair of legs move alternately.

These rather unusual gaits were refined by a Russian nobleman, Count Alexis Ovlov in the mid-eighteenth century. Many of today's trotters can trace their lines back to Ovlov breeding. In Britain, the Norfolk trotter and the Hackney horse were predominant. But it was perhaps in the United States, where the breeding of trotters intensified, producing some spectacular results. They were derived from imported horses, particu-

larly those ridden by the overseers of tobacco plantations, who had to ride many miles every day around their farms. Not surprisingly, with so much riding, they used horses with the most comfortable gait or pace. From these plantation horses, as they were known, the standard-bred was developed. The name standard-bred refers to the fact that the horse could reach the standard speed of 2 minutes 30 seconds per mile, for a trotter, and 2 minutes 25 seconds for a pacer. The distances raced in harness racing are normally 1.6 km (1 mile) in the United States and up to 3.2 km (2 miles) in Europe.

As with flat racing the American tracks are flat, but with banked curves, whereas European tracks are wider and sometimes undulating. A trotting race is normally started on the move. The horses, commonly eight in a race, line up behind a motor vehicle that has a wide rail attached to the back of it. The vehicle gradually moves up to the starting line with the horses behind the rail and as it crosses the line, accelerates away allowing the horses to race. A judge's car often follows the horses around the inside of the track to ensure that none of the horses

FACING PAGE: *Harness racing in Germany. The European tracks are sometimes undulating, testing both rider and horse.*

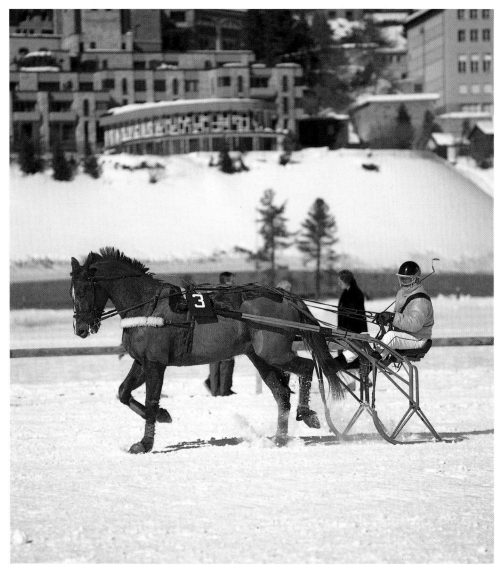

'break'; that is, go from a trot into a canter, which can lead to the horse being placed last.

The breeding of racehorses and trotters has become a multi-million pound business and a colt (young male horse) that has had a successful racing career (for instance, winning a classic race such as the Derby) will become enormously valuable and command very high fees to 'serve' or mate with mares. The stud farms in places such as Kentucky, the Blue Grass State of the United States, are palatial and the French Duc d'Aumale, mentioned earlier, would not feel out of place were he to be re-incarnated as a horse on one of these farms. The stallions are housed in their own barns, each with its own paddock, and during the mating season will serve mares which are brought to the stud farm. The number of foals each stallion sires is carefully controlled in order to retain the exclusivity of his line, and in the event of his offspring being successful on the race track, the stallion's stud fee escalates tremendously.

Of all the glamorous locations where racing takes place, perhaps the frozen lake in St Moritz, Switzerland, is the most exotic. Perched high in the Engadine

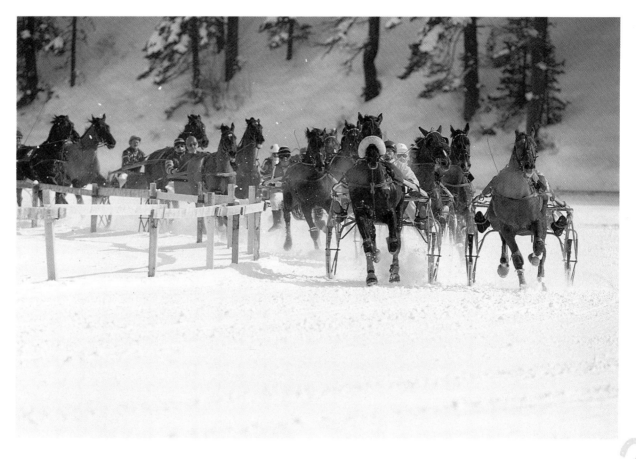

RIGHT AND FACING PAGE:
*Harness racing at St Moritz,
Switzerland – a stunning setting
for an intensely exciting event.*

Mountains, the lake at St Moritz freezes in the winter to a depth of several metres, allowing a race course to be laid out. In February several race meetings are held which include flat racing, hurdling, trotting and the unique *Skijoring* where a skier is pulled by a horse, making for a very exciting spectacle. The surface of the lake is covered in fine snow, which is hard and creates a surface very similar to sand. The horses wear special studs on their shoes to stop them from sliding.

39

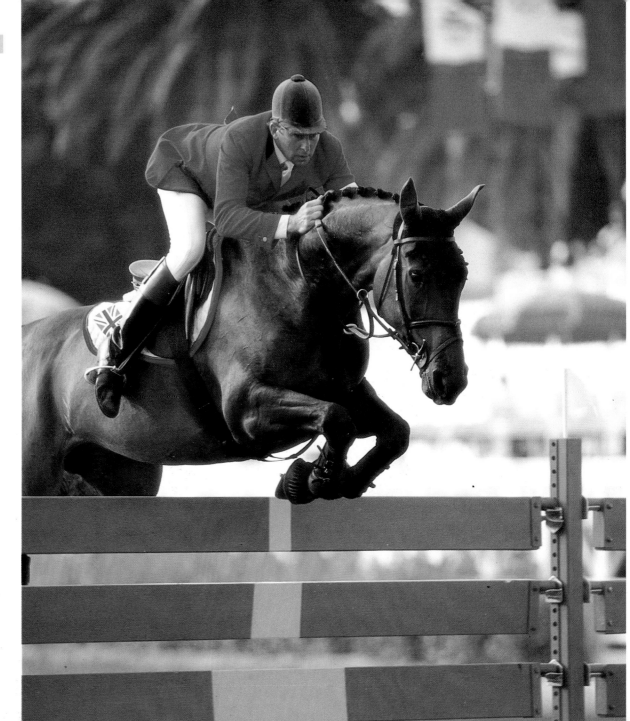

RIGHT: *Nick Skelton rides Dollar Girl to victory in the 1992 Olympics.*

Competition Horses

Since early Roman times the horse has been used in sport and its major function in the Western world is to take part in competitions, ranging from show jumping to endurance riding.

Show jumping is a relatively modern sport and the first competitions were held over a single upright jump built to test the height that the horses could jump. Paris held one of the earliest competitions in 1866, followed by the United States in 1883. Some phenomenal heights were cleared; in 1902 the American Dick Donnelly on his thoroughbred Heatherbloom cleared a 2.5 m (8 ft 2 in) fence.

Alongside the sports of eventing and dressage, show jumping became included in the modern Olympics in 1912 at Stockholm. The first individual winner, Frenchman Jean Cariou on Mignon, started a thirty-year domination by cavalry officers. As horses were gradually dropped from their military role, civilians took over as the top competitors, and at the Helsinki Olympics in 1948, French wine grower, Pierre d'Oriola, riding Ali Baba, took the gold medal.

Show jumping is a popular television sport, as all the action happens in a comparatively small area in front of the camera. The latest technology gives the viewer access to the most exciting angles, as tiny cameras, no bigger than the size of an egg, can be hidden in the fences. Every move can be analysed by the commentators with immediate action replay. Such strong public interest commands commensurably high prize money.

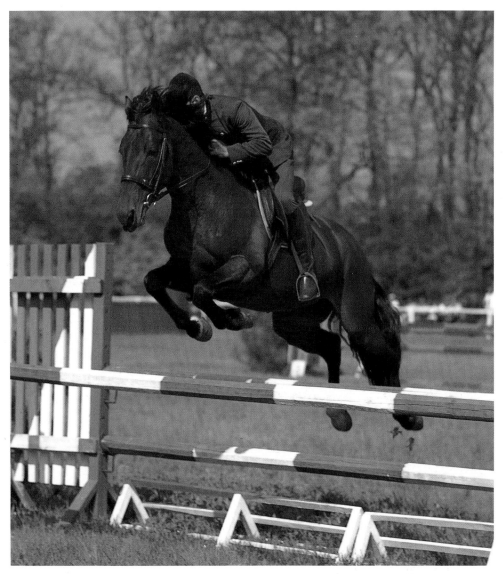

Through the media, a number of horses and riders have been raised to superstar status. The adulation which horses such as Milton (with his rider John Whitaker) receive as they enter the arena certainly bears this out. Milton, a beautiful grey bred in England, is known as Milton the millionaire, having won over a million pounds.

One of the most beautiful sights in equestrian terms is the top-class dressage horse and rider in action. It could almost be described as ballet on horseback, such is the delicate balance between grace and precision of movement, and the rapport between horse and rider. The demands of riding the set test requires immense concentration by horse and rider.

Dressage is a sport where perfection is the elusive goal. The dedication required for top-class honours means that very few riders ever attain them, and you only have to watch those who win to realize how much time, patience and skill have gone into achieving that success.

LEFT: *Because of the rich prizes and keen public interest in the sport, top show-jumping horses are extremely valuable.*

The dressage horse comes in all shapes and sizes, but many of the top competition horses are of German breeding or of other European bloodlines. A good number have Thoroughbred blood in them and were bred specifically for dressage. For the less ambitious rider, however, there are plenty of horses capable of doing the job quite satisfactorily, providing that they have correct straight paces and a certain amount of elevation in their stride.

Dressage is proving to be one of the fastest expanding horse sports in the world today, and there is a growing number of people who, having been inspired by the experts, are prepared to devote their spare time to improving their own riding. The myth that dressage is for those who cannot jump has long been dispelled.

Although forms of dressage have existed since Roman times, the Spanish Riding School, with the beautiful white Lipizzaner stallions, is one of the oldest established schools of dressage, dating from the sixteenth century. Their famous 'airs above the ground', which include the astounding movements known as capriole and courbette, have thrilled audiences all

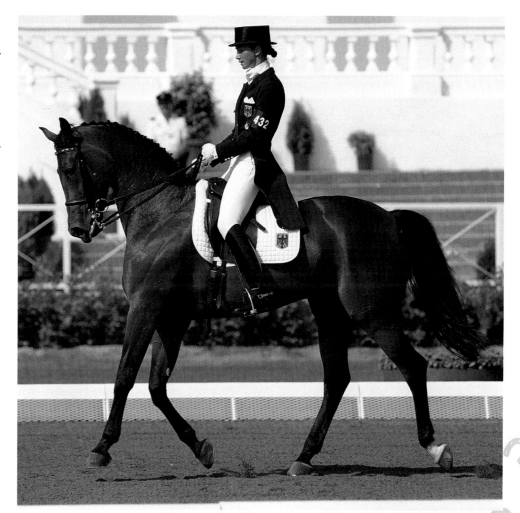

ABOVE: *Together, Nicole Uphoff and the aptly-named Rembrandt are a world-beating dressage team;* *they have won the world title, the European championship and gold medals in two Olympic Games.*

43

over the world, and it is always worth seeing them if you can at their home base in Vienna, Austria.

When dressage first became an Olympic sport at the Stockholm Olympics in 1912, the Swedish home team dominated the sport. In recent years the Europeans have swept the board internationally, with the current champions being the Germans, closely followed by the Dutch.

Germany seems awash with able dressage riders and horses. Isabell Werth with her chestnut mount, Gigolo, policeman Klaus Balkenhol with Goldstern and Monica Theodorescu and Grunox, are all famous competitors in their own right, and made up the gold-medal-winning team for the Barcelona Olympics. Monica won the 1994 World Cup dressage-to-music competition, the Kur, with Grunox. This competition incorporates set movements that have to be executed to music, with marks being awarded for artistic impression and technical performance, not dissimilar to ice dancing. The competition has become very popular with the crowd, who often get so carried away by the music that they join in with rhythmical clapping.

Event Riding

Horse trials, whether the less demanding one-day event or the more exhausting three-day event (though this may be stretched to four if the dressage requires extra time), are an all-round test of horsemanship. Originally conceived by cavalry officers as peacetime training for their mounts, the trials (which require stamina and versatility) remain known as the 'Military' in Europe.

Eventing consists of a variety of levels. The basic one-day trial for young horses or novice riders includes a straightforward dressage test, testing the obedience and schooling of the novice horse; cross-country, which at this level should be inviting and require some boldness, but not be too gruelling; and show jumping, which will test horse and rider for accuracy. The advanced horse and rider tackling the highest graded five-star three-day event have to undergo a far more technical dressage test incorporating movements only a little less exacting than those of the pure dressage. Consequently event riders, able to tackle the most daunting cross-country course, have had to become very competent dressage

riders to succeed at their sport.

One of the most famous equestrian events in the world is the Badminton Horse Trials, a three-day event held in Britain since 1949 on the Duke of Beaufort's estate. Badminton is almost a victim of its own popularity. With an annual crowd of over 250,000 over the four days, many people now visit the event on one of the less-busy dressage days, preferring to watch the thrills and spills of the cross-country action on their televisions at home.

The cross-country event includes two endurance phases, A and C, which are run over distances of between 16,060 and 19,800 metres (10 and 12 miles). These are separated by the speed element of the event, the steeplechase, Phase B, run over a course of ten typical chase fences, in a time of four-and-a-half to five minutes (near racing speed), with penalty marks for each second over the optimum time.

The most exciting spectacle is the final

RIGHT: *Some of the world's most proficient equestrians (such as New Zealander Mark Todd, shown here) have been event riders.*

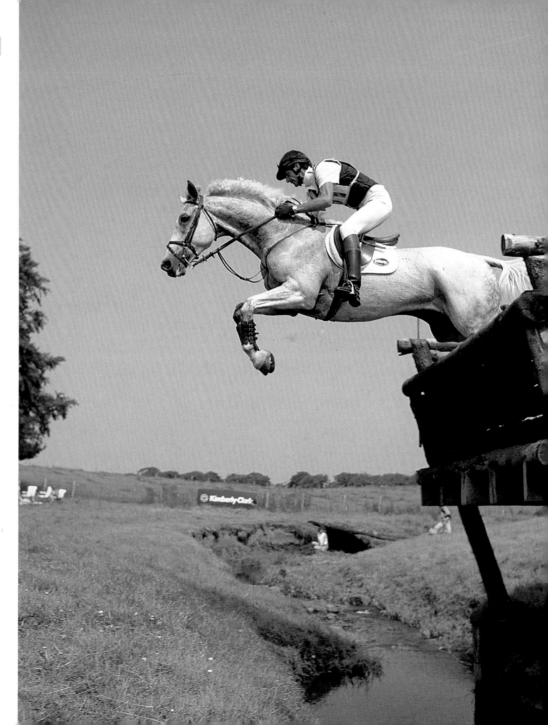

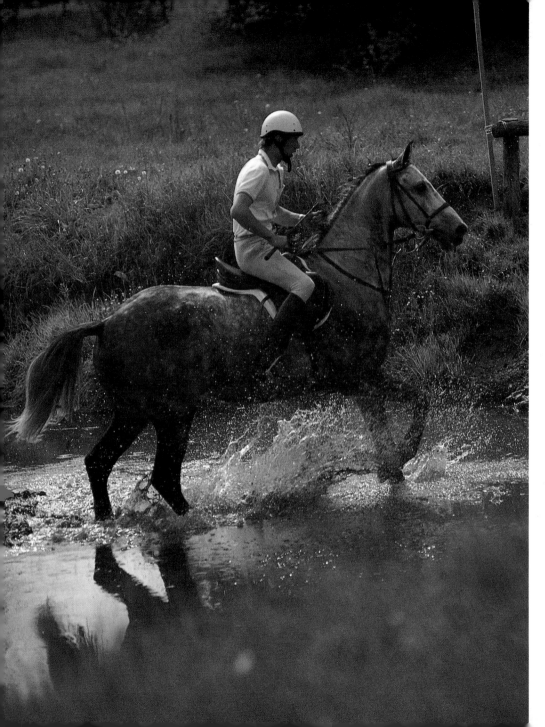

Phase D. Jumping a wide variety of twenty-eight to thirty obstacles, with a maximum height of 1.2 m (4 ft) requires a fearless combination of horse and rider. Although the jumps are essentially solid and imposing, the top rails are roped on and can be quickly dismantled in an emergency.

There is no doubt that the endurance phase of a three-day event is stressful and demanding. Consequently, each horse is required to have a full veterinary check before the start of competition and several times during the day, when its heart rate, dehydration levels and temperature are checked. Although there is no mandatory veterinary check at one-day horse trials, any unsoundness detected by the dressage judge will be reported, and the horse must be examined by the official vet before being allowed to continue.

New Zealander Mark Todd, on his wonderful mount Charisma, won individual Olympic gold medals in 1984 and 1988. Charisma, although only 15.3

LEFT: *Eventing demands skills in dressage, cross-country and show jumping.*

hands (160 cm), easily carried Mark's 1.9 m (6 ft 4 in) frame. Mark is considered the consummate horseman, putting his all into every sport he enters. At the Seoul Olympics, he was the only rider to compete in both the three-day-event and show-jumping competitions.

Other Sports

Cross-country also forms part of competition driving. Whether you have a team of four horses or ponies, a pair, or a single, it can be most entertaining. Negotiating the cross-country hazards or obstacles requires precise timing and judgement. The hazards, which are generally gaps between solid wooden posts just wide enough to allow the vehicle to pass through, are ingeniously designed with intricate twists and turns.

In a similar competition to the eventing tests, combined driving is a three-day affair, with the first day given over to the presentation or dressage phase. The vehicle used has to be of smart and elegant appearance, with each competitor being judged on turnout and condition of the vehicle, driver and the two accompanying grooms. They then proceed through the

set ten-minute test, during which they have to perform a series of circles and serpentines at trotting and walking speeds, finishing with a halt.

For the marathon section, the driver uses a purpose-built vehicle, with super-tough qualities to withstand any impact with the obstacles and travelling at speed across rough terrain over the 10 km (6 miles). The marathon is divided into sections as in eventing, with the endurance phases covering over 29 km (18 miles). Although it is not yet compulsory for the driver to wear a hard hat, the official who accompanies the team must now be suitably protected as it is not unusual for the vehicle to tip over as it negotiates awkward obstacles at speed. Each hazard has a set time, above which penalties are awarded.

The two grooms that travel on the team vehicles are an essential part of the outfit. They have to cope with any emergencies on the route (for example, any legs over the traces or harness), but should the groom dismount in the middle of an obstacle, he or she must get back on board before leaving the penalty zone. When occasionally the groom has had to

47

dismount during the water hazard, there have been scenes of great hilarity as the poor groom has floundered in their attempts to catch up with the disappearing vehicle.

On the final day, each team has to drive through a short obstacle course made up of cones which are easily knocked over at a minimum speed of 21 km/hour (13 mph). Each knock-down costs five penalty marks, which may make all the difference between winning and losing. The general rule is that the competitors start in reverse order, making for a good climax to the competition.

The Hungarians, Poles and, more recently, the Dutch have had great success in driving and since the start of the World Driving Championships in 1972, the winning team has been Hungarian no less than four times. Dutchman Tjerd Velsta and his team of Dutch warmbloods are the top medal winners on the world front, winning the individual and team titles at the World Equestrian Games in Sweden in 1991.

A relatively new sport on the calendar is horse ball. Initially played in France, it is similar to basketball but played on horseback. It is growing in popularity throughout Europe, with over 300 teams in France alone. As with polo, the co-ordination between horse and rider is essential, the game requiring great dexterity as frequent sharp turns have to be made.

The game proceeds like this: two teams of six riders, only four of whom are allowed on the field at once, try to gain possession of the ball. This is fitted with six leather handles and must be passed from rider to rider at least three times on the way to goal. The goal, similar to a basketball net, is a 1-metre (39-in) hoop on the top of a 3.4 m (11 ft) pole.

The game is carried out at great speed, with much passing of the ball, and is not for the faint-hearted. The hardy French Anglo-Arab horses are favoured for this sport, and are trained to perform half-turns, flying changes and rapid accelerations at a touch.

Showing classes for horses are more of an exhibition than a sport, but provide an excellent showcase for the more beautiful specimens. Horses and ponies in these

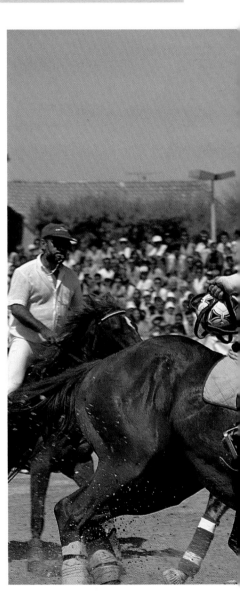

RIGHT: *Horse ball is an exhilarating and demanding sport that has become particularly popular in Europe.*

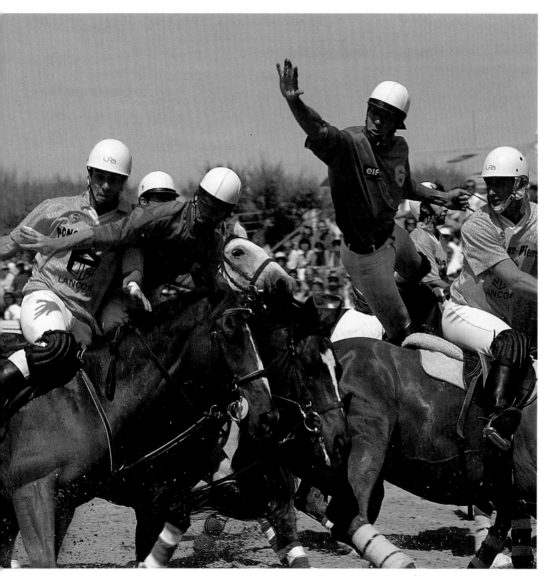

competitions are judged according to their conformation, action and, in the case of hunters, their ride. British classes judge each horse both in action and standing still, and, after studied inspection, the judges make their selection. In the last few years, the American idea of incorporating jumping and dressage into the competition has led to the introduction of the competition horse classes, which have proved very popular. The pony classes at county shows can have line-ups stretching the whole length of the arena, particularly if the winner qualifies for a major show, such as the Horse of the Year show held at Wembley.

Endurance riding is all about getting from start to finish in the shortest possible time, while conserving the horse's energies. Many long-distance rides take place over a 24-hour period in which the horse and rider have to cover some 160 km (100 miles) along a route of varying terrain. On particularly steep trails, the riders will dismount and run alongside to conserve their horses' energy.

The horse's pulse, respiration and general soundness are checked at regular intervals along the course by veterinary surgeons and each competitor's back-up

team is placed at strategic points along the route to water and sponge down the horse and provide much needed sustenance for its rider.

Several specially designed saddles have been made to ensure the comfort of both horse and rider, as the stresses and strains of unsuitable tack can easily result in galls. At the end of each ride, the horse is assessed by a panel of vets, who award points for recovery rate and soundness, on which the judges base the results.

Probably the most popular mounts are Arab horses who lend themselves well to endurance riding, the double world champion being the Arab gelding Grand Sultan ridden by American Becky Hart, who also won the U.S.A. national championship.

One of the most glamorous horse sports, polo, is also one of the oldest. First played by the Ancient Persians, it is more commonly associated with the wealthier sectors of society, though thriving local clubs can be found the world over.

The costs of running a high-goal polo team can be enormous. The majority of the top teams are made up of professional players, with the team patron, often a dedicated amateur, playing with them. Each player is given a goal rating according to their abilities. Teams are equally matched so that the total of the players' ratings are the same.

Many of the best ponies and players originate in South America. Several of the players are from families who have excelled at polo for generations, including such names as the Heguy brothers, Gonzalo and Horatio, and Eduardo Moore. The tough Argentinean ponies used to be favoured by most players, but now many use the Thoroughbred. Speed and ability to turn have made the thoroughbred or Argentinean/Thoroughbred cross supreme in the sport. To run a team, each player may need as many as six ponies for the season, as they can use up to three ponies in one match. Games are divided into chukkas, each one lasting seven-and-a-half minutes. Six chukkas are played in the top-class high-goal matches, four in local games.

Polo is one of the fastest ball games in the world, with the ponies travelling at speeds of up to 56 km/hour (35 mph). Watching a top-class player hitting the ball into goal at full gallop can be exhilarating. The ponies often know the game as well as their riders, following the ball

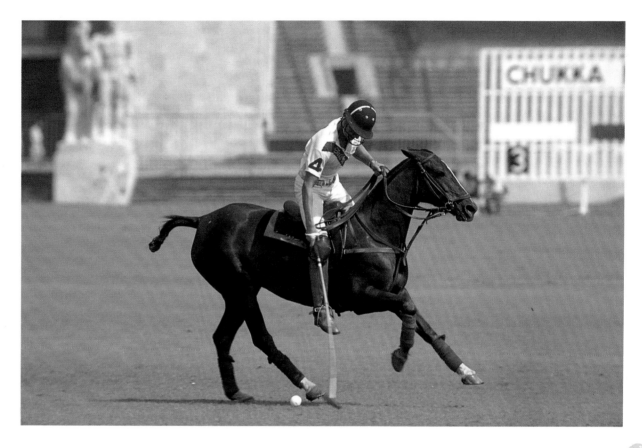

RIGHT: *The annual polo tournament on the Maifeld, in West Berlin.*

of their own accord, and responding quickly to changes of pace and direction. Good communication between horse and rider is essential for this fast-moving game.

With polo fields set in exotic locations, polo matches tend to act as a draw for the rich and famous. From the Palm Beach polo ground in Florida to the more formal setting of the Guards polo club at Windsor Great Park and the private grounds of tycoons, polo, despite its ancient origins, is still the preserve of the wealthy classes.

51

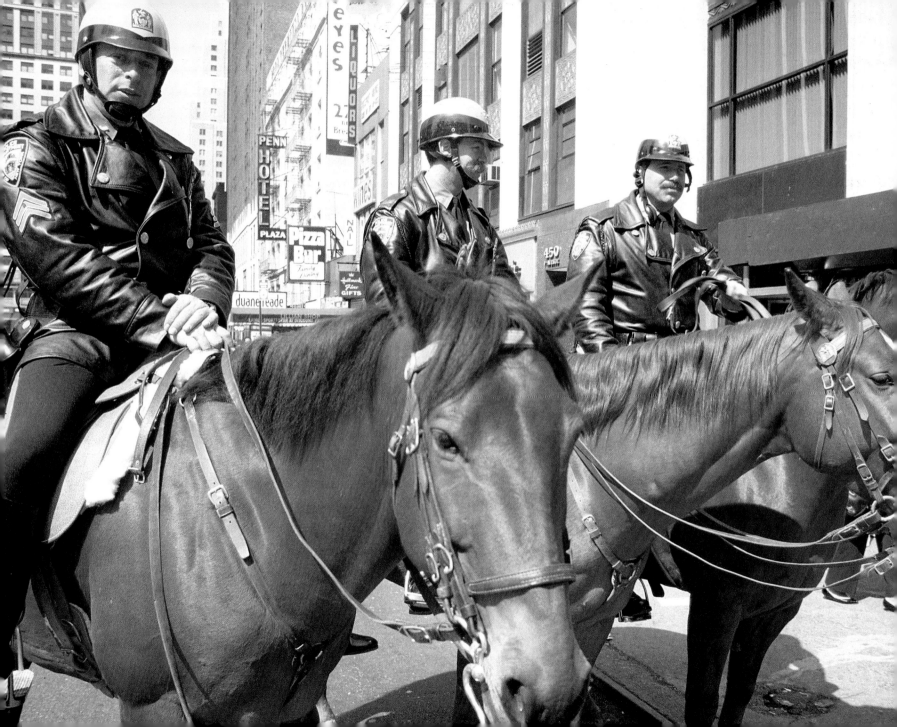

Working Horses

It may come as something of a surprise to find that the vast majority of the world's horses are in fact working horses. Whether harnessed to carts, sleds or carrying a load, they are often vital to the livelihood of their owners. Even before the invention of the wheel, which was to revolutionize the world, horses had been used as pack animals and as a means of transport and still are today in some of the more inaccessible mountainous parts of the world, such as Tibet and South America, where they are considered a necessity. Smaller, lightly built horses and their cousins, the donkeys, are adept at climbing some of the most precarious paths carrying large loads, and often are left to follow each other, picking their own way on trails that no motor vehicle could attempt to pass. In many developing countries the use of the horse as a pack animal is as common now as it was in years past. The expense of purchasing and running a motor vehicle, compounded by the difficulty of obtaining spare parts ensures the continued use of the horse as a working animal.

The use of horses in battle is said to have changed the course of history. From as early as 2000 BC the Kassites and Elamites, along with other nomadic peoples of the steppes, put their ponies' speed to use in winning battles for land and goods when negotiations had failed. The marauding Mongol hordes of Ghengis Khan and his cavalry conquered such enormous areas of land from northern China, across Asia to Eastern Europe,

that almost defy the imagination, but with fleet cavalry his destruction was carried out in the space of twenty years. Even today this would seem a great accomplishment.

The chances of success in battle were often dependent on the quality of the cavalry horses, and many different types of horses were employed. Napoleon Bonaparte favoured a grey Arab, Marengo; the Duke of Wellington a chestnut thoroughbred, Copenhagen. Copenhagen survived his conquests and died in retirement at the ripe old age of twenty-eight. Early use of the horse in battle was confined to hand-to-hand fighting, and the art of classical riding which used high-school movements of horse and rider evolved as a military exercise to aid the soldier in combat. Many of these movements are still performed by the Spanish Riding School in Vienna and the Cadre Noir in Samur, France. The later introduction of heavy armour both for horse and rider required a more substantial type of horse, hence the appearance of the 'great horse' which, although considerably larger than the earlier cavalry horse, was by no means in the league of the modern-day heavy horses.

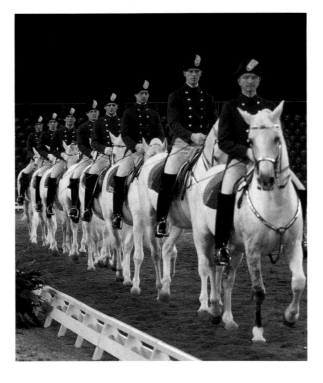

LEFT: *The Spanish Riding School still uses movements originally developed for horses in battle situations.*

FACING PAGE: *Mounted regiments such as Britain's Horse Guards now have a mainly ceremonial role.*

Even up to the middle of the First World War when tanks were first introduced, a great number of horses were employed either at the front, moving gun-carriages or bringing up supplies at the rear. It is a poor solace that these brave animals were of great necessity to the soldiers they served, given that they had to endure, as did the men, the most appalling conditions. Many thousands of

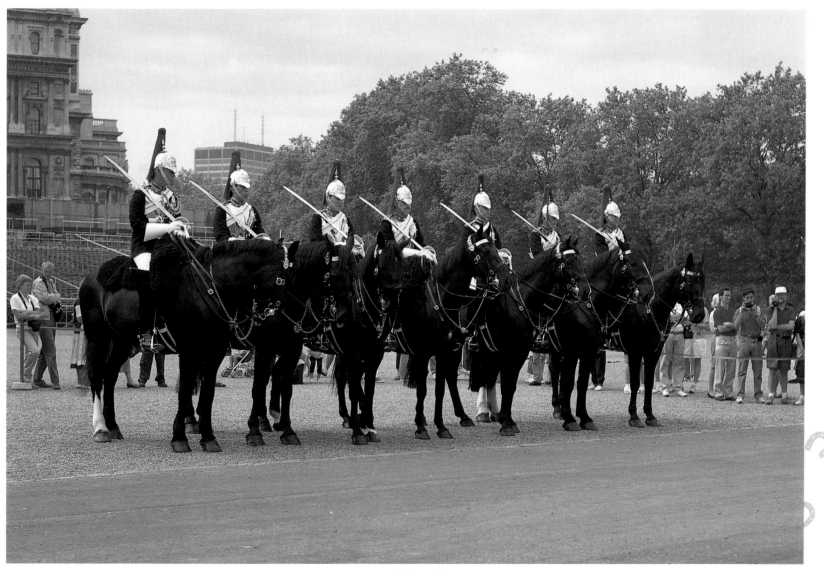

horses were killed during that war.

A number of countries still maintain their most prestigious mounted regiments in some form. In Britain there is the Household Cavalry made up of the Life Guards and Horse Guards, whose role now is to provide escorts for state occasions and royal weddings, and mount guard at Buckingham Palace. They are also a popular attraction when they appear annually at the Royal Windsor Horse Show, held in the grounds of Windsor Castle in May with the accompaniment of the spectacular drum horse, with its splendid kettle drums, and the mounted troopers with their trumpets.

Some of the earliest wheeled vehicles were chariots of war recorded as early as 1600 BC. The use of the chariot made it possible to speed up the movement of a whole army, as each chariot could mount a driver, a shield-bearer and an archer. In more recent history, horses were used to mobilize gun carriages. The drivers riding the near-side horses were capable of riding at a gallop and also supported the cavalry.

Although the horse has been in demand on the battle field for some 4,000 years, its use has now (understandably) diminished. At first it was given a variety of peacetime uses including pulling loads and carrying its master on hunting expeditions. The myth of the noble war horse reduced to that of a beast of burden didn't really stand up as it would have compared unfavourably to the ox or the donkey, which were already employed in the fields. The running costs of the ox would have been considerably lower than that of the horse, with the benefit to the farmer that they could sell their fattened ox for meat at the end of its working life, unlike the horse which was of little value to a nation which did not normally eat horse flesh. These disadvantages, however, would have been set against the greater speed of the horse versus the ambling gait of the ox.

With the development of the horseshoe which kept the horse's feet sound and unworn by the rigours of work, and the manufacture of useful harness to attach the horse to a machine, the horse soon became part of the way forward. The increase in human population required greater amounts of food for both humans and animals, and the invention of horse-powered machinery speeded up the slow systems of land cultivation. The invention

FACING PAGE: *Over the years stronger horses were bred that were better suited to heavy agricultural work.*

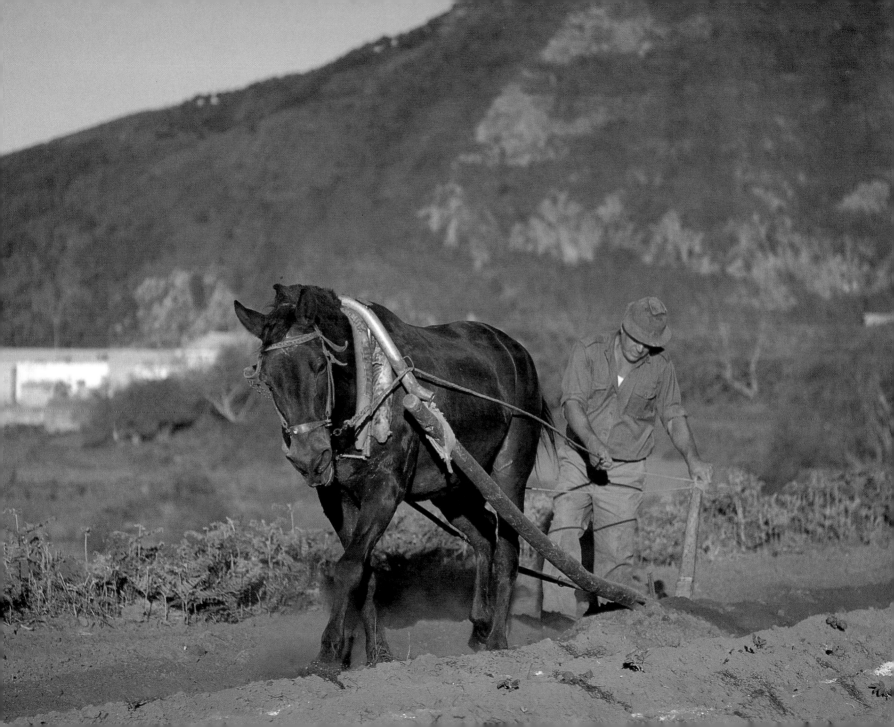

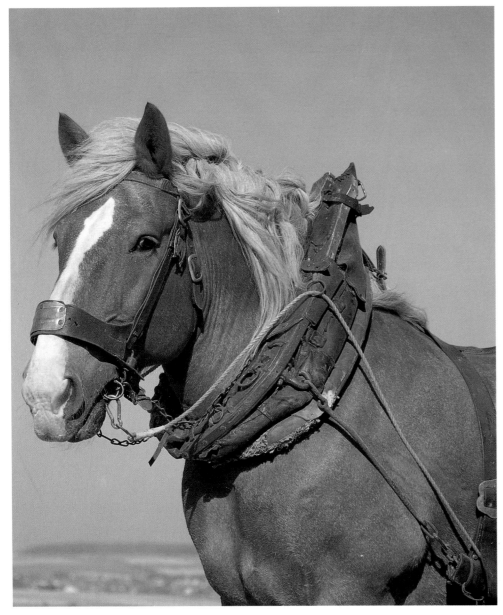

of the swing plough, for instance, meant that two horses could turn over more ground in a day than could six oxen, and by the mid-nineteenth century great developments had been made, including the appearance of machines for thrashing the corn. The combine harvester was to prove a godsend. Pulled by a massive team of forty horses, it could not have achieved its potential in the vast expanses of land in the New World without the co-operation of the horse.

Transportation was another use to which the horse was put. By the early Middle Ages, transport in the form of carts, not unlike those used by the Romans, appeared all over Europe and by the sixteenth century, public transport in the form of stage coaches were in use in England. These must have been most uncomfortable as they had no springs and consequently travelled at a snail's pace. The first coaches were immensely heavy and required very strong horses to pull them along what were mostly

LEFT: *Generally speaking, the horse has not been used widely for agricultural purposes.*

unmade roads. Most coaches were pulled by four horses and were in general use over most of Europe as well as in America, where the early settlers used covered wagons as their homes until they found permanent homes.

Private coaches in a variety of forms were the prerogative of the wealthy, many of which were most stylish. These included the Landau, an open gig used for driving in the parks to 'take in the air' and the Brougham, which was covered for more inclement weather. A more elegant type of horse was used for this transport, embodying quality and style to set off the smart outfit. No doubt many of these horses were well cared for and lived a life of comparative luxury, which would have been in stark contrast to the horses that pulled the London cabs. With approximately 22,000 horses employed in cab transport in the 1890s, there were bound to be those that lived a dismal life, being cruelly overworked and badly treated.

RIGHT: *Horses are an important element in the annual City of London Lord Mayor's Show.*

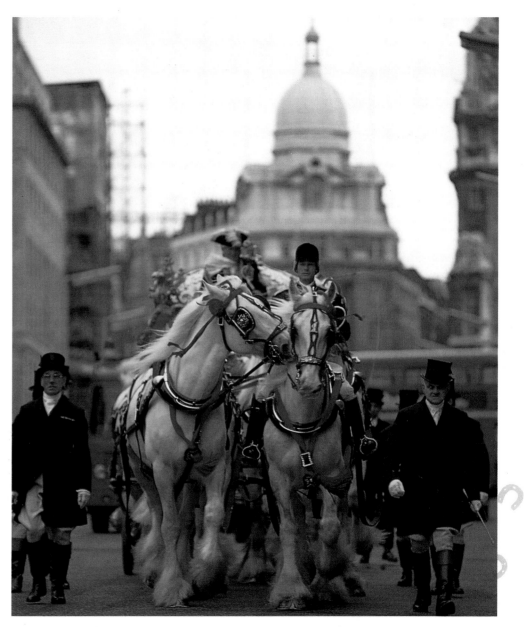

By 1890 the London horse population had risen to an estimated 300,000, most of which were employed to pull a variety of heavy loads including trams, cabs and buses. Several large companies, such as the Great Western Railway Company, used horses in many different ways, ranging from the shunting of railway carriages about the depots, to local delivery of the goods transported by the trains. At one time over 500 horses were used by the company, most of which were kept at excellent stables in Paddington, which stood at over four floors high with stalls at each level. These horses, though they worked hard, were carefully selected and trained for their work, but even so the average work life of each was only five years.

One of the toughest jobs for a horse at the turn of the nineteenth century was that of pulling trams. The trams ran on rails laid in the ground, and were pulled by horses harnessed to them. The rails were often covered in debris, making the already heavy weight of the tram very difficult to pull. This would put particular strain on the tram horses' hind legs as they took the weight of stopping and starting. It would appear that although there were recognized tram stops, the trams would pick up a passenger at any point, putting even more strain on the horses. Consequently, there was a great waste of horses and they seldom lasted more than four years in this service.

The pride of the London horses at this time were the brewery horses, which were widely admired. The annual parades usually climaxed with the brewery horses, which were often worth treble their counterparts' value, taking all the ribbons. Buyers came from fall over the world, particularly from America, where they were in great demand. Some brewery horses were sold for enormous sums, including the purchase of a stallion for £2,500 – a tremendous amount at that time. The modern brewery horse still receives much admiration, and you can sometimes see them making deliveries in some of the larger cities of the world. The decorated brewery horses taking part in Munich's annual Oktoberfest attract a huge crowd of spectators.

Carriage horses in modern-day Britain are mostly used by royalty on state occasions, such as coronations, weddings or the state opening of Parliament. With the splendour of the gilded decoration and

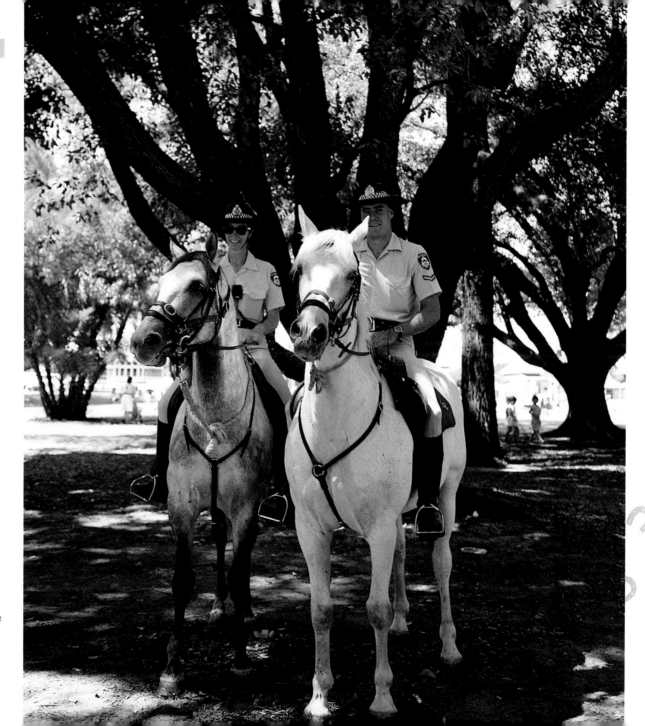

RIGHT: *Mounted police in Western Australia play a part in crowd control and patrolling busy streets.*

the 'Windsor grey' horses, it is indeed a wonderful sight. The Royal Mews at Buckingham Palace house the royal collection of carriages and are open to the public. Several of the mail coaches of days gone by have been restored to their former glory and appear with their beautifully matched teams of horses for coaching marathons or filmed historical dramas.

The police horse is always a welcome sight. Whether controlling crowds at football matches or patrolling busy streets, they are always immaculately turned out. The original British police horses were part of the Bow Street organization, employed for speedy action against the criminal element. Each horse has to go through rigorous training during which it has to learn to accept every sort of sudden loud noise and nuisance. It has to take the strain of leaning against pressure in preparation for crowd control, and at no time must there be any suggestion of panic. The modern-day police horse now wears protection at football matches and at other potentially disruptive occasions, and is supplied with eye shields against acid attack or missiles.

One of the most famous mounted police forces in the world are the Canadian Mounties. They were responsible for policing an enormous area of land – over 777,000 sq. km (300,000 sq. miles) – and even bred their own remounts on a stud farm at Assindoine Camp, producing the beautiful black horses for which they became famous. Mechanized transport, however, has now taken over and the force is purely a ceremonial outfit.

In the wilder parts of the world, horses are still used to herd cattle and sheep. When the terrain is steep and rough and beyond the range of motor vehicles but still carries stock, a sure-footed horse is the only answer. The cowpony in the United States, an essential mode of transport for the cowboy, is trained to take the strain on the rope when a cow is lassoed, so that its rider can dismount and walk up to the animal, with the pony holding the pull. In many parts of Australia, cattle graze over such a wide area that rounding them up can take as much as two months. The stockhorses used must be agile, hardy and resilient. In Mongolia, the local ponies are still used for herding cattle, for despite their size, they are remarkably strong and quite capable of carrying an adult.

FACING PAGE: *A rider with an agile horse is still one of the best ways of rounding up cattle over large areas.*

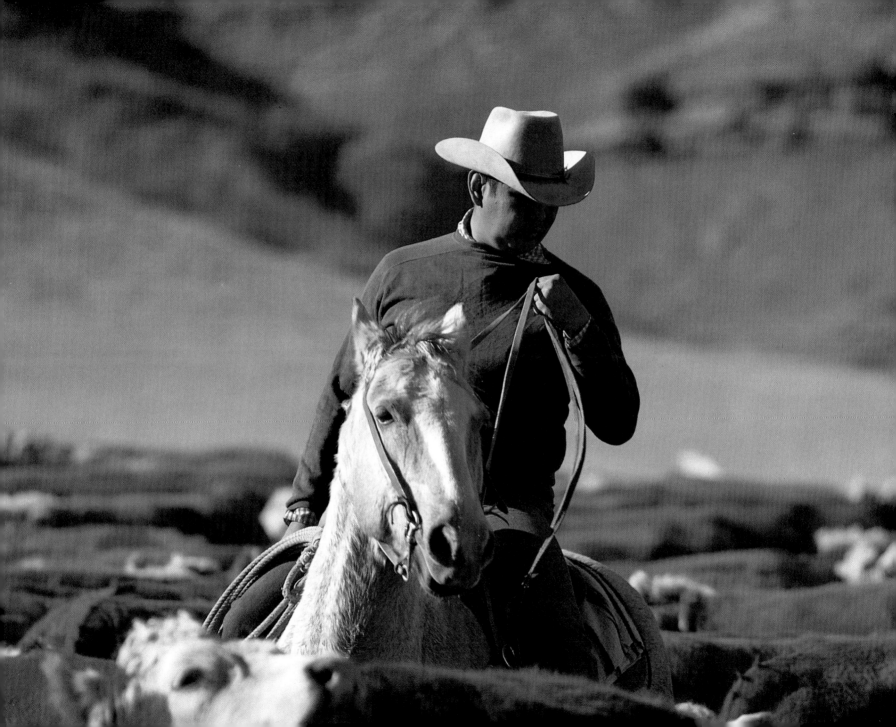

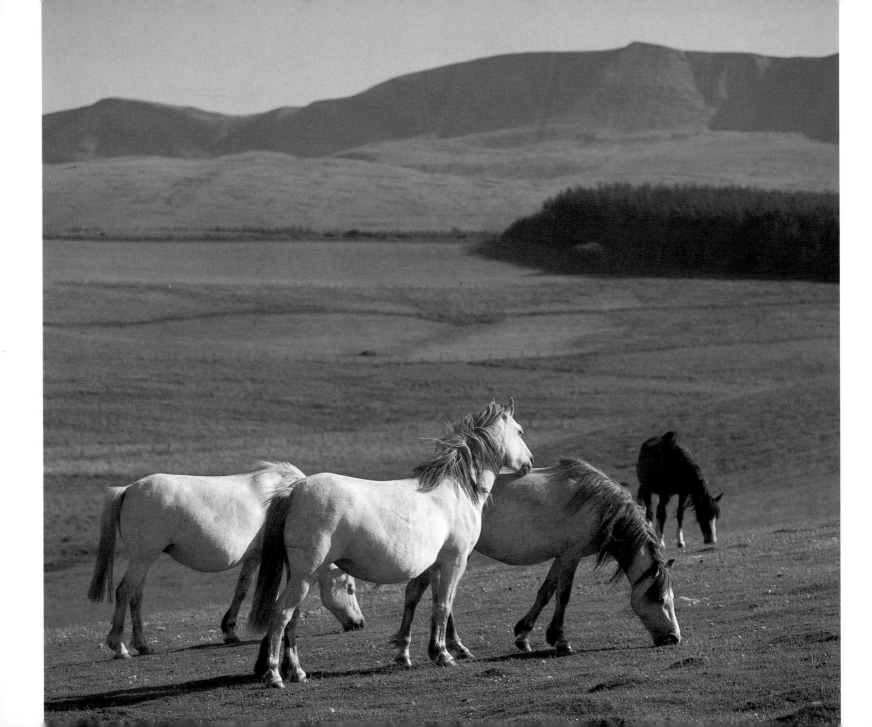

Horse and Pony Breeds

From the tiny Falabella, which stands at less than 86 cm (34 in), to the massive shire horse standing at least 188 cm (74 in) high, there is an enormous variety of sizes, shapes and colours within the different breeds of horse.

The principal colours of ponies and horses are brown, bay, chestnut and black, while many of the more ancient breeds are dun. There are many grey ponies and horses but this is not thought to be a true colour but a pigmentation variation. No horse or pony, unless it is an albino, is ever born white; instead it starts out as black or bay and develops into a grey as it grows older. Most foals change their coat colour as they mature and it is not until they are about two years old that the final colour is estab-

lished. A bay horse always has 'black points' – a black mane, tail and black markings from the knees down. A brown horse will be much the same colour as a dark bay but will have a brown mane and tail and brown legs. There are very few black horses, but to qualify as truly black the horse must have a black muzzle. Chestnuts come in many shades, from liver chestnut (a dark rich brown) to pale gold. The dun colours of the ancient breeds range from yellow to mouse dun with a dark mane and tail and an 'eel' stripe, which is a black line running the length of the spine. Roans are flecked with white hairs and can be one of three shades: strawberry, blue or bay. The palomino has a rich golden colouring, the colour of a newly minted copper coin.

FACING PAGE: Welsh mountain ponies grazing in their natural habitat.

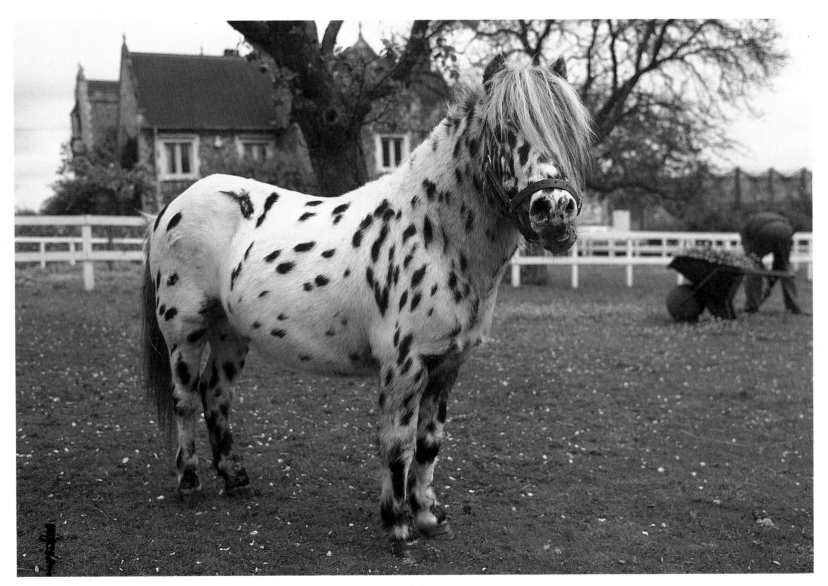

Coloured horses and ponies can be skew-bald (brown and white) or piebald (black and white). The Appaloosa is a spotted horse from America, which can come in variations such as leopard, snowflake, spotted blanket and white blanket, all of which depend on the way the spots fall! The only true white horse is the albino which has pale blue eyes and a pink skin.

A pony must be under 147 cm (58 in) from the withers, while horses start from 147 cm (58 in) and range upwards. It is not just the size difference, however, which distinguishes horses from ponies. Ponies are descended from a mixture of the primitive Celtic and northern European horses and have evolved shorter legs, which makes them stockier and able to carry or pull larger weights in relation to their body size. Also, as ponies have fewer uses to humans than horses, their development has been allowed to follow a more natural course, unlike their larger cousins. There is virtually no breed of horse which has not been 'improved' by humans through selective breeding, a process which is on-going. Consequently, some of the older breeds of draught (pulling) horses disappeared when they were no longer of any use.

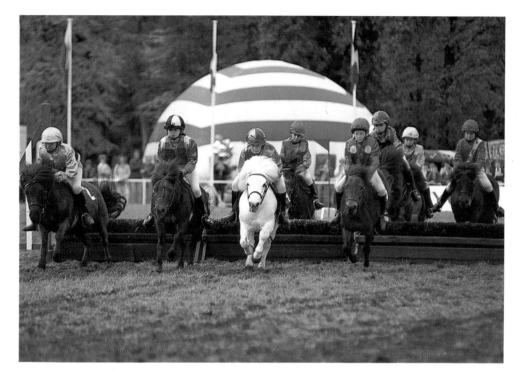

Horses can be put into three distinct categories: hot-blooded, cold-blooded and warm-blooded. These descriptions have nothing to do with the temperature of the horse's blood but are a way of describing their temperament. The hot blood refers to an Arab or thoroughbred horse which tends to have a fiery temperament, whereas a cold-blooded horse is usually a draught working animal such

ABOVE: *The Shetland Grand National is a popular event that draws massive crowds of spectators each year.*

FACING PAGE: *The Falabella is a compact breed, standing less than 86 cm (34 in).*

as the agricultural horses of France. The warmblood is the result of crossing the two types and it is here that the most significant developments in breeding have taken place over the last hundred years. The warmblood is the competition horse of today and dominates the world of dressage, show jumping and, more recently, eventing.

The original characteristics of horses and ponies were determined by their environment and climate. The area with the richest diversity of pony breeds is the British Isles where, thanks to isolation from Europe, the British ponies have evolved over many hundreds of years to give a number of different types that are used and crossbred throughout the world.

Breeds of Pony

Living at the extreme north of the British Isles, the tiny Shetland pony more than makes up in sheer strength what it lacks in size. Measuring up to 102 cm (40 in), the Shetland is capable of carrying a man over rough country and bearing heavy loads, and was used on the crofts of Scotland and in many coal mines. It is bred extensively all over Europe as well as in the United States and Australia. Ideal for small children, the Shetland works well in harness. One of the most popular sights at county shows throughout the United Kingdom in summertime is the Shetland Grand National. The ponies parade before the race just like racehorses and set off with their young riders to gallop over a course of small brush fences. Over the years many thousands of pounds have been raised for charity by the Shetlands.

The New Forest pony is one of the largest British breeds and one of the most popular as a riding pony. As the New Forest lies in such an accessible part of the country, not surprisingly there has been a great deal of mingling of pony types over the years, with particular influences contributed by the Welsh ponies and the Arab and Barb horses. Most New Forest ponies are bred in stud farms nowadays, but there is still a large number of wild ponies owned by the local people who hold traditional grazing

RIGHT: *The Lusitano is widely used for dressage, being intelligent and eager to please.*

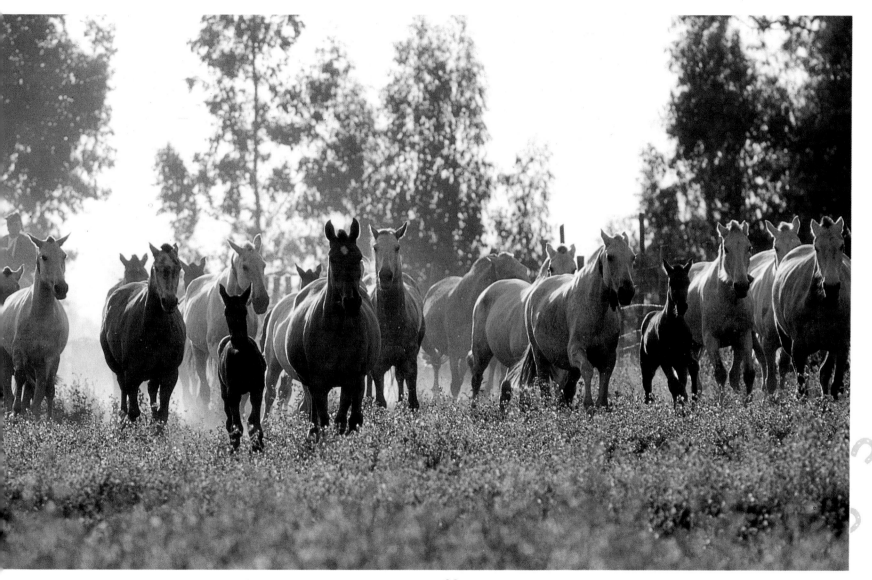

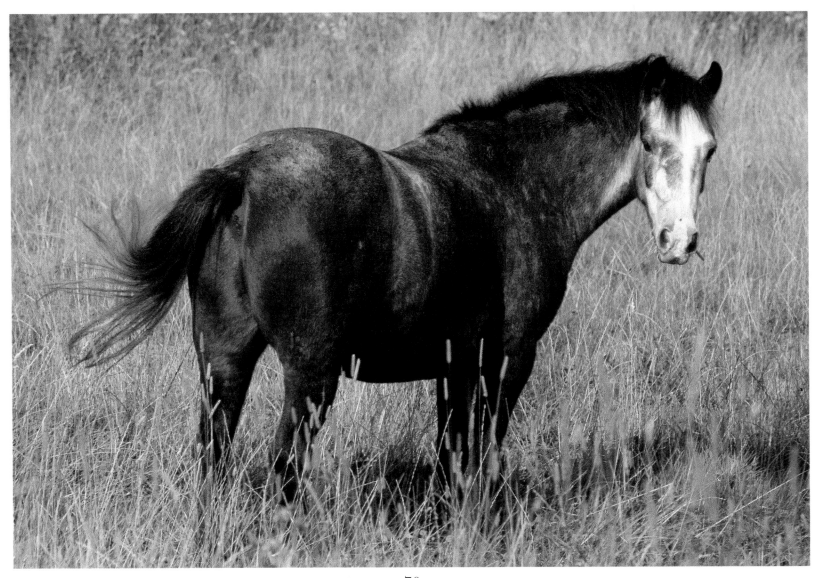

rights. An all-round pony, the New Forest is a favourite for jumping and showing.

From the extreme south-west comes the Dartmoor pony, which also makes an excellent riding pony. The Dartmoor, although originating on the bleak moors, has been subject, like the New Forest pony, to outside influences. Dartmoor straddles the link between Exeter and Plymouth, and because the traders who used this route would cross Dartmoor ponies and horses bearing a dash of Arab, Welsh and thoroughbred blood in their veins, the Dartmoor, as a result, is a most elegant riding pony, and very popular in Europe.

The Dartmoor's nearest neighbour, the Exmoor pony, is by contrast one of the oldest and purest of the native ponies. The isolation and harshness of their environment has meant that the Exmoor has retained some of the characteristics of its ancestors. It has a 'toad' or hooded eye, 'mealy' coloured muzzle and tough guard hairs which enable the Exmoor to graze on the gorse bushes which grow in profusion on Exmoor. More independent than other breeds, the Exmoor does make a good children's pony and when crossed with a thoroughbred can produce a par-

ticularly tough and able performance horse.

The Welsh ponies are split into three different types. The Welsh mountain (Section A), which stands up to 122 cm (48 in) high, is the most beautiful of the Welsh breeds, roaming the Welsh hills long before the Roman occupation of Britain. It was the Romans who introduced the Eastern influences of the Arab horse to the Welsh ponies.

The Welsh riding pony (or Section B) is larger and more versatile than the mountain pony, and is much in demand as a jumping and show pony. The Welsh Cob type (or Section C) was called the farm pony. The cob-type pony makes an ideal driving pony.

The Dale and the Fell pony are closely related coming respectively from the eastern and western side of the Pennine Mountains. They were developed as pack ponies to carry lead ore from the moorland mines. Today the ponies, which stand around 1.4 m (56 in), are used mainly for competitive driving.

The Highland pony, like the Exmoor, is a very ancient breed. It is, however, a stronger type of pony thanks to the influence of the Clydesdale heavy horse. Their

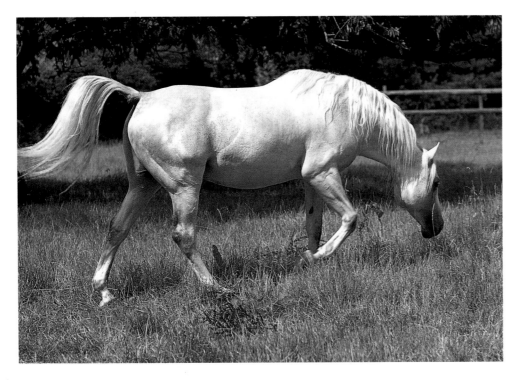

ABOVE: *An Arab stallion inspects his territory.*

FACING PAGE: *Clydesdales in full regalia at a ploughing match.*

Ireland has only one breed of pony and that is the Connemara, which originated on the western seaboard of Ireland. Probably the most versatile of the pony breeds, it is ideal as a jumping pony and appears at top-class competitions worldwide. The predominant colour of the Connemara is grey although they can range from bay and brown to dun.

The wild ponies of the Camargue, in southern France, are known as 'white horses of the sea' because of their distinctive white colouring. These sure-footed ponies are ideal for herding the black bulls that are bred in the Camargue, and as mounts for tourists exploring the region.

Horse Breeds

colouring ranges from grey through all shades of dun to a dark mouse colour. Another sign of the pony's ancient lineage is the eel stripe (a dark line running the length of the pony's back) and 'zebra' stripes on the leg. Its main uses are in forestry (for pulling logs), hunting (for carrying deer carcasses off the hills) and for trekking, being very sure-footed and having a docile nature.

The most well-known and easily recognized of the working horses in the Western world is the Shire. Descended from the medieval great horses of England, which were ridden into battle by knights in armour, the Shire is one the largest horses in the world, often measuring up to 183 cm (72 in) high and capable of pulling great weights. A majestic animal, it has a very quiet temperament, and

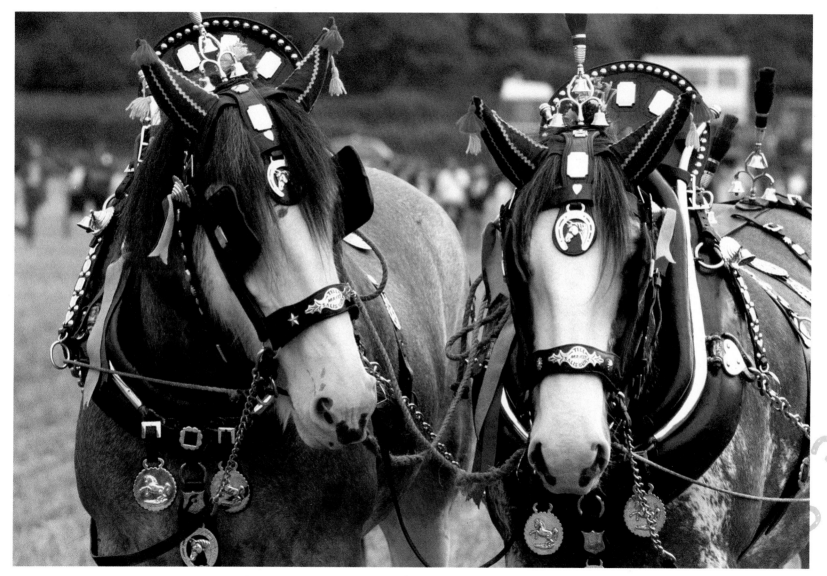

teams of these horses can sometimes be seen pulling brewery drays in the busy city streets, where they have been found to be more economic than the lorry.

Germany is famous for its beer, and brewers continue to use horse drawn drays to deliver supplies. On special occasions, such as an anniversary or the opening of a new inn, the heavy draught horses and their drays are decked out in ornamental harnesses and headgear. At festivals, each horse is fitted with a metal muzzle to stop it nipping bystanders.

Clydesdales fulfil a useful function in some of Britain's parks doing various jobs, including rolling and harrowing the grassland and collecting plant debris. In the United States a splendid team if these horses is used at the Santa Anita race course, California, for re-siting the starting stalls.

On the European mainland there are dozens of different types of heavy or work horses, and France can lay claim to having the most breeds. They have been preserved for two reasons: firstly, France has a tradition of state-run studs for horse breeding; and secondly, horse meat is eaten throughout Europe and this entails a steady demand for the heavier horse.

This system was developed by Napoleon during his conquests in Europe to ensure a steady stream of horses for his cavalry and draught horses for keeping the armies supplied. In Britain this state stud system was never developed in the same way; being a seafaring nation, the demand for horses was never as great.

The Comtois is a lightly built but tough draught horse from the Jura mountains between France and Switzerland. It is a sure-footed worker, popular with farmers in mountainous regions. The powerful Ardennais comes from the Ardennes region on the borders of France and Belgium. This ancient breed is thought to have descended from the war horses of the Middle Ages; more recently, it was used as an artillery horse during the First World War.

Further to the east and in the area of the Arabian peninsula, the horses became lighter and wirier to cope with the arid conditions of steppe and desert. It is in

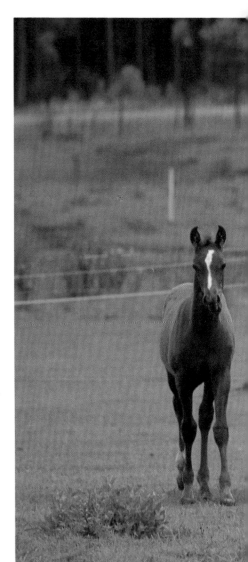

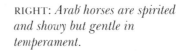
RIGHT: *Arab horses are spirited and showy but gentle in temperament.*

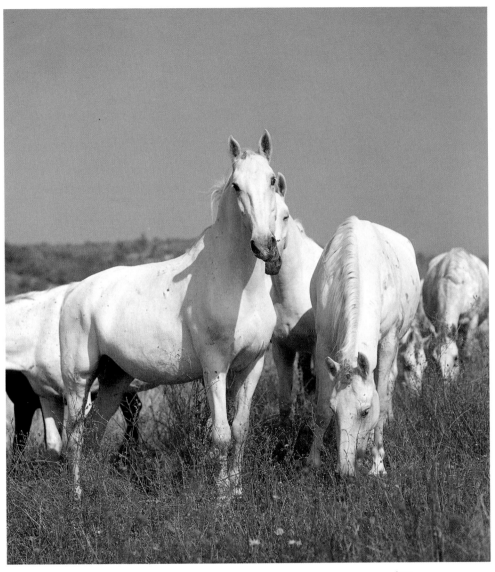

this area that the Arab horse evolved and the Akhal-Teke, believed to be one of its predecessors, is one of the most strikingly coloured horses to be found anywhere. Its predominant colour is a pale honey gold with a metallic sheen.

The horse which has had the most influence in the Americas must be the Andalusian. A Spanish horse whose origins go back to the Barb horses of North Africa, the Andalusian was introduced by the Spanish colonists. A spirited animal, the Andalusian is renowned for its high-stepping athletic gait, making it popular as a cavalry horse and ideal for the high-school movements which became popular during the Renaissance. These movements were later to formulate the basis of modern dressage; the Andalusian provided the foundation stock for the grey Lipizzaner horse which still performs today in the Spanish Riding School in Vienna. The Lipizzaners are trained to perform a series of movements both with and without riders, perhaps the most

LEFT: *The Lippizaners in the Spanish Riding School use movements originally intended to keep foot soldiers at bay in battle.*

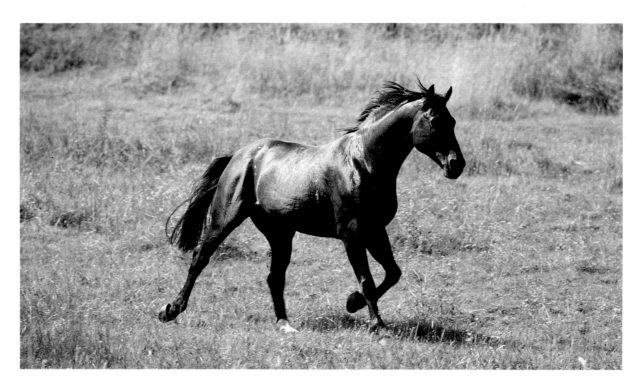

famous of these being the courbette, where the horse springs into the air at the same time as throwing out its hind feet.

The largest growing type of horse today is the warmblood. A mixture of thoroughbred and the more placid breeds of carriage and working horses, the warmblood started its rise to popularity in Germany where there are now many different types. Perhaps the most famous of the warmbloods is the Hanovarian, which was bred up from local farm horses using imported English thoroughbreds. It now produces Olympic-class show jumpers and dressage horses. To be able to keep up with fashion in the horse world, the breeders of many warmblood horses will introduce outside blood lines to improve or alter the type of horse they produce to suit the current

ABOVE: *The Hanovarian is bred for a level-headed and willing temperament and energetic movement.*

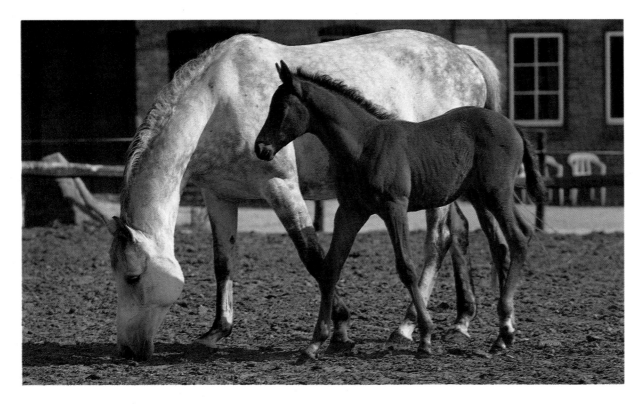

LEFT: *A mare with her filly is a graceful and tranquil sight.*

demand. The system of state studs in Germany is constantly testing and monitoring the performance of the horses they breed in the hope of producing the ultimate sports horse. Holland, although only a small country, has one of the world's most sophisticated breeding programmes for sports horses.

The relationship between humans and horses is as strong as ever but is constantly evolving to reflect the change in people's needs. It is now realized that the older breeds which may not be so relevant to modern life have to be preserved to keep a large and healthy pool of genes which can be drawn on to introduce pure blood to the ever-growing ranks of the mixed-breed horse.

Index